Deleuze Reframed

Contemporary Thinkers Reframed Series

Deleuze Reframed ISBN: 978 1 84511 547 0
Damian Sutton & David Martin-Jones

Derrida Reframed ISBN: 978 1 84511 546 3
K. Malcolm Richards

Lacan Reframed ISBN: 978 1 84511 548 7
Steven Z. Levine

Baudrillard Reframed ISBN: 978 1 84511 678 1
Kim Toffoletti

Heidegger Reframed ISBN: 978 1 84511 679 8
Barbara Bolt

Kristeva Reframed ISBN: 978 1 84511 660 6
Estelle Barrett

Lyotard Reframed ISBN: 978 1 84511 680 4
Graham Ralph-Jones

Deleuze Reframed

A Guide for the Arts Student

Damian Sutton
& David Martin-Jones

I.B. TAURIS

Published in 2008 by I.B.Tauris & Co. Ltd
6 Salem Road, London W2 4BU
175 Fifth Avenue, New York NY 10010
www.ibtauris.com

In the United States and Canada distributed by Palgrave
Macmillan, a division of St. Martin's Press, 175 Fifth Avenue,
New York NY 10010

ISBN: 978 1 84511 547 0

A full CIP record for this book is available from the British
Library
A full CIP record for this book is available from the Library of
Congress
Library of Congress catalog card: available

Typeset in Egyptienne F by Dexter Haven Associates Ltd, London
Page design by Chris Bromley
Printed and bound in the UK by TJ International, Padstow, Cornwall.

Contents

Acknowledgements vii

List of illustrations ix

Foreword: *Deleuze reframed?* xi

Part One

Introduction. What is a rhizome? 3

Chapter 1. Gaming in the labyrinth 11

David Martin-Jones

Chapter 2. Virtual structures of the Internet 27

Damian Sutton

Part Two

Introduction. What is becoming? 45

Chapter 3. Minor cinemas 51

David Martin-Jones

Chapter 4. Becoming art 65

Damian Sutton

Part Three

Introduction. What is duration? 85

Chapter 5. Movement-images, time-images and 91

 hybrid-images in cinema

David Martin-Jones

Chapter 6. Time (and) travel in television 107

Damian Sutton

Conclusion: Reframing Deleuze 123

Notes 129

Select bibliography 137

Glossary 141

Index 145

Acknowledgements

This book is the product of many fruitful discussions that we have had together over many years, as well as discussions we continue to have as scholars of philosophy and visual culture. We have both been excited and frustrated by Deleuze, and we both continue to enjoy the cut and thrust of the debate over his work, and are genuinely thankful that we were introduced to a philosopher who could make so many new thoughts arise in us. We are aware that Deleuze and his work can seem remote or impenetrable to others, however, and thus it is also from the discussions we have had with colleagues and students that we have been able to focus our attention on the extraordinary contribution of Deleuze to philosophy, as well as his contribution with Félix Guattari. We have resolved to help others understand what we consider to be the most important concepts that Deleuze developed, and we hope that this guide is successful in introducing new thinkers to Deleuze and his work. We hope the reader will not stop at this book but remain thirsty for more by and on Deleuze, as we do.

There are numerous commentaries on Deleuze, and many useful analyses made that help develop his ideas and provide new methods of understanding. It has been a great privilege to get to know so many of those writers from whom we have drawn ideas, and who have become welcome friends and colleagues. This guide would not have been possible without the fruitful and challenging discussions we have had with them, almost too numerous to mention. For support, information and inspiration we would like to give special thanks to Antonio Carlos Amorim, Bettina Bildhauer,

Philip Drake, Amy Herzog, Laura U. Marks, Bill Marshall, Helen Monaghan, Soledad Montañez, John Mullarkey, Nicholas Oddy, Patricia Pisters, Anna Powell, John Rajchman, Angelo Restivo, David Rodowick and Karen Wenell. In addition, we would like to thank the staff in our departments for their support, and especially the students in our undergraduate and postgraduate classes at Glasgow School of Art, Northumbria University and the University of St Andrews. In particular, thanks should go to students on the MA in Film Studies at Northumbria University in 2003–4, for engaging debates over recent films such as *The Cell*. Finally, we would like to thank the editorial team at I.B.Tauris for helping us develop this guide, and for their advice and support throughout.

List of illustrations

Figure 1. *Mysterious Skin* (d. Gregg Araki, Desperate Pictures/ Antidote Films, 2004) supplied by the Ronald Grant Archive. 59

Figure 2. Rachel Whiteread, *House* (1993) courtesy of the Gagosian Gallery © Rachel Whiteread. Photo credit: Sue Ormerod. 77

Figure 3. *The Cell* (d. Tarsem Singh, New Line Cinema, 2000) supplied by the Ronald Grant Archive. 99

Figure 4. *Doctor Who* (BBC, 2007) copyright © BBC. 113

Foreword: Deleuze reframed?

This book is a brief introduction to some of the key philosophical motifs, theories and approaches of one of the twentieth century's most important philosophers, and one whose ideas have strongly influenced our passage into the twenty-first. Gilles Deleuze (1925–95) was born in Paris, and studied under Ferdinand Alquié and Jean Hyppolite. As a philosopher he developed a fairly predictable career, which saw him work at l'Université de Provence and later at l'Université de Paris VIII, Vincennes/Saint Denis, where he worked until he retired in 1987. His colleagues included Jean-François Lyotard, Michel Foucault and, perhaps most importantly, Félix Guattari.

The impact of Deleuze's philosophy is far from predictable, however, and the works that he produced over his lifetime – on Immanuel Kant, Baruch Spinoza, David Hume, Friedrich Nietzsche, Foucault, Henri Bergson and Gottfried Leibniz, among others – do not rest on the bookshelf of the philosophy professor's office, but create resonances in new artworks, new visual communications, new philosophies. Unlike the works of some of his contemporaries, including that of Foucault and Lyotard but also Jean Baudrillard and Slavoj Žižek, Deleuze's philosophy is seldom used as just an interpretative mechanism for cultural criticism. Instead, Deleuzian ideas arise in the Internet, in cinema, television and in visual arts, in architecture and political thought. Cultural motifs such as 'non-linear' thought, for example, can be traced back to Deleuze's work with Guattari, most commonly appearing under the heading 'rhizomatic', or 'rhizomorphic'. In the last few years some of the

contemporary philosophical world's most important thinkers –
including Žižek, Alain Badiou, Michael Hardt and Antonio Negri –
have turned to Deleuze and the legacy of his prolific work.
Deleuzian ideas have influenced scholars of history and economics,
as well as those in politics, gender studies, and in art and design
theory. Deleuzian influences can be seen in the work of Vilém
Flusser, for example, whose nomadological writing has been
revisited in theories of visual culture, and Deleuzian ideas echo
in the work of Bruno Latour, one of contemporary sociology's
brightest minds in the study of technology and culture. This is why
we felt that the time was right to develop a book such as this; a
book that we hope will be an invaluable companion for someone
meeting Deleuze for the first time, and which will act as a
springboard for a new thinker toward new ideas and concepts, new
productive relationships between philosophy and creative practice.
We will introduce the new thinker (artist/designer, professional
scholar, student) to some of the key ideas Deleuze developed
through his career, through his adoption of earlier philosophers,
and in his collaborations with Félix Guattari (1930–92).

 We came to this project having worked on our own as critical
thinkers, finding as we talked together persistent issues about
which we shared interests and concerns. We had both noted, for
instance, the growing widespread interest in Deleuze, which
excited some colleagues and exasperated others. We also noted
some of the shortcomings of Deleuzian debates, however, which
seemed to be mired in the practice of quoting him like scripture.
This seemed to oppose the dynamism that Deleuze's practice of
philosophy itself illustrated, as in his ability to return to earlier
philosophers and develop a relationship with them that leaps
beyond quotation and produces something new. Famously,
Deleuze's practice has been described (by him and others) as that
of taking other philosophers from behind, an invasive act that
produces by 'immaculate conception' a child of both. But it is
also an approach, that Ian Buchanan has described as a 'calculated

creativity', about knowing when ideas can be taken further, when to return to the text, and when to pick up new texts and broaden one's scope.[1] This book, for example, is a productive result of individual and collective thinking as we continue to work with Deleuze, and continue to read him.

Deleuze used a number of philosophical tactics that we have tried to adopt here. The first is the principle '*ad fontes*', which in Latin means 'to the sources'. Deleuze's tactic of 'taking philosophers from behind' meant that his relationship to their works bordered on the intimate. While it is easy to see the influence of Bergson, for example, in Deleuze's own philosophy of time, this can also give rise in the writing to a kind of bickering or lover's quarrel between philosopher past and present. Certainly, when Deleuze returned to Bergson in the 1980s the result was a realisation of a lover's renewed passion. This is why, even when Deleuze worked with Guattari, we have kept with Deleuze as the lead philosopher in that partnership, because, while their work undoubtedly developed its own unique concepts, when Deleuze collaborated with Guattari he was in fact already in collaboration with Nietzsche, Bergson and others, and it is the ideas from these collaborations that give Deleuze's philosophy its characteristic voice.

A second tactic that Deleuze employed is illustrated best in his last work with Guattari, *What Is Philosophy?*[2] The underlying principle of this is to ask a question that will give rise to new concepts in an *alloying* with the creative product. It is the mistake of the one-dimensional theorist to have the theory of the arts in mind and then take it to the artwork. Instead, we must start with a hunch about the philosophy, and then see where this is given rise in the artwork. So Deleuze and Guattari begin with becoming and get to Paul Klee, begin with *affect* and get to the monumental. A new concept can therefore be taken back to understand again a conceptual power in the work of an artist long written off (as in Robert Mapplethorpe, we might argue here). Similarly, a new creative form might better illustrate, and even give new dimension

to, a concept already developed, as in the case of minor cinemas. The point here, as John Rajchman suggests, is not that creative practice cannot do philosophy, but that to do philosophy is 'to fabricate concepts in resonance and interference with the arts'.[3] Philosophy cannot do art (in being 'applied' to art as a theory) any more than art can do philosophy, but instead they have the capacity to raise new thoughts through the mutual contagion, 'in which both art and thought come alive and discover their resonances with one another'.[4]

We have chosen to ask 'What is a rhizome?', 'What is becoming?' and 'What is duration?', because it is from these that we can really get to grips with the usefulness of Deleuze. We have taken in discussions of immanence, psychoanalysis and the body without organs along the way, but it is these three concepts that constitute Deleuze's most productive legacy, and which have the capacity in the right hands and minds to inform a creative life. These three questions provide a structure for the book, and we explore them using original analysis of examples from contemporary visual culture.

The first part introduces the idea of the rhizome as an ever-expanding labyrinth without centre, capable of either opening up new horizons or closing down possibilities. In our first chapter, 'Gaming in the labyrinth', David Martin-Jones examines the computer game as illustrative of the interaction between the rhizome and Platonic thinking. The video game provides a multifaceted example of the ways in which a rhizomatic understanding of visual culture (and especially our conception of Deleuzian de- and reterritorialisations of identity) often depends as much on the manner and context in which we use different media as it does on the specificities of the medium. Accordingly, the different types of identity that gamers experience might visit such contrasting extremes as coloniser or guerrilla fighter. Next, Damian Sutton develops this in terms of online space and social resistance, in our second chapter, 'Virtual structures of the

Internet'. Virtual structures are those created by television, telecommunications and, most recently, the architectures and environment of the Internet. Deleuzian thinking, focused on the rhizome, has been instrumental to our understanding of the Internet and the 'shape' it took in its early years, and to the critical idea of the Internet as promising a democratic access to information and communication that offers us unlimited movement and freedom.

We then move on to study social formation through resistance and through difference, and to do so we look at these in cinema and art as illustrative of 'becoming'. 'Becoming' is drawn from Deleuze's opposition to existentialism and 'being', his opposition to psychoanalysis, and his interest in the vitalism of the universe – indeed, it forms the basis for much of Deleuze's philosophy. Deleuze and Guattari's proposal for ethical social resistance, for example, was that we must understand otherness through becoming 'Other' ('becoming-woman', 'becoming-animal', 'becoming-minoritarian'). In our third chapter, 'Minor cinemas', David Martin-Jones uses Deleuze and Guattari's analysis of Franz Kafka to help understand the role of minor cinemas in political and social critique. Kafka's grotesque, surreal and bizarre world could be interpreted as a critique of the colonial situation in which he wrote. His idea of making major forms of literature stutter or stammer, to open up the hierarchies they inform, can be applied to a number of minor cinemas – Senegalese, Turkish, Quebecois among others. In this instance, recent US independent cinema is examined as a minor cinema. For our fourth chapter, 'Becoming art', Damian Sutton shows how Deleuzian political thought has coincided with a visual arts practice that is often profoundly militated against capitalist ideology, the structures of the canon and even the notion of the artwork itself. Underlying this is perhaps Deleuze's most important gift to critical approaches in contemporary art – a theory of *percepts* and *affects* that explains why particular artworks have such a lasting creative, monumental effect.

We turn in the last part to the 'substance' of organisation, the full potentiality of time itself. Deleuze was profoundly influenced by Bergson, and he found in his work a theory of time from the point of view of the experience of life. From here Deleuze developed his own philosophy of time, one that is best understood through our plastic representations of it, such as cinema. In chapter 5, 'Movement-images, time-images and hybrid-images in cinema', David Martin-Jones explains how Deleuze's philosophy of time is expressed in the movement-image, which creates a linear narrative by focusing on the moving body of its protagonist, and the time-image, which attempts to represent the virtual movement of time itself. The chapter then demonstrates how recent hybrid films that contain aspects of both images explore the difference between space and time, and the parallels they draw between the mind and the body, dream and reality, and new media and film. After this, in chapter 6, 'Time (and) travel in television', Damian Sutton looks at science fiction television to illustrate how Deleuze's philosophy provides for an understanding of our perception of time, through his development of Bergson's gift to philosophy: the realisation of mental becoming, informed by memory, within which we live. Deleuze and Guattari also look for the absolute ground of life itself, the energy and forces that make up becoming, given shape as an idea of the pure, simple universe that lends itself toward organisation. This is demonstrated in the ways in which we tell stories, and the ways in which we narrate and explain our experience of the world and its possibilities.

Deleuze's philosophy was rooted in a sense of usefulness, intended as a productive philosophy of life. These are philosophies that have one eye on the future, and on how we must live. This means that the value of his ideas can be tested by their continued usefulness, on the one hand, and their ability to give rise to new concepts on the other. Hence we have tried to include sharp recent and contemporary examples from creative media – Internet, video games, television, as well as art and cinema – that allow Deleuze's

ideas to develop beyond some of the forms with which he was familiar. The aim of this approach is not that we should say what this or that philosophical idea means, but that we should provide ways for new thinkers to see an idea in new creative forms, even as the idea changes and generates anew. We have chosen examples to illustrate Deleuze's writing, but also his ideas and their afterlife, as they are taken up by others or as they form a constellation with philosophies past and present. In many of the chapters we have tried to give a sense of the wider histories and debates that our case studies have, informed at every stage by our Deleuzian analysis. Most important of all, we have tried to use examples of how – as individuals, as a society, as culture – we demonstrate concepts to ourselves. We often use the visual arts to tell stories, of course, but it is easy to forget that they are also employed to conceive, elaborate and discuss fundamental aspects of living: our relationship to society and meaning, our relationship to growth and subjectivity, our relationship to time and the immensity of duration. We have reframed many of Deleuze's ideas so that the new reader and new thinker will have the courage and tenacity to pick up Deleuze's books and see new iterations of, and challenges to, his conceptual project in the visual arts.

Part One

Introduction

What is a rhizome?

In literal terms, the word 'rhizome' refers to a plant stem that grows horizontally underground, sending out roots and shoots. Many grasses are rhizomatic, as are any number of common plants found in our diets, including asparagus, ginger and the potato. When Deleuze and Guattari used the term in their introductory chapter to *A Thousand Plateaus: Capitalism and schizophrenia* (1980), however, they did so to describe a certain way of thinking.[1] The image of roots and shoots emerging from a horizontal stem encapsulated a manner of thinking that they favoured over the dominant thought process of Western philosophy. Dating back to the ancient Greeks Plato and Aristotle, this dominant Western model is causal, hierarchical, and structured by binaries (one/many, us/them, man/woman, etc.), and has been the dominant form of thinking in Western society for several thousand years.

Due to its emphasis on cause and effect and the creation of hierarchies, Deleuze and Guattari compared the dominant Western model of thinking to the tree. This image refers not only to the literal shape of a tree (the seed is the cause, the tree the effect), but also – for instance – to the genealogical lineage attributed to ancestry in the family tree. In a family tree there is an obvious causal relationship between a single point of origin (the father) and his offspring. Thus the image of the tree expresses how the dominant model of Western thinking creates a single version of the truth (one tree, seemingly living in isolation – or, if you like, one father and one family), from which the 'Other' is then defined – the

space around the tree, or that which is 'not tree'. This type of binary thinking has a long tradition and is still dominant today, although in the late nineteenth century the German philosopher Nietzsche (1844–1900) began to point the way toward another way of thinking. Greatly influenced by Nietzsche (Deleuze wrote *Nietzsche and Philosophy* in 1962), Deleuze developed the idea of the rhizome with co-writer Guattari.

Deleuze and Guattari did not establish rhizomatic thinking in opposition to the dominant Western model, however. It is not exactly a case of tree versus rhizome. Such a move would have recreated a binary opposition (in this case, between right and wrong ways of thinking), consistent with the dominant Western model of thought that Deleuze and Guattari were attempting to rethink. Rather, they felt that we should reconsider how we think. In a sense, the image of the rhizome was supposed to 'supplant', if you can forgive the pun, the image of the tree. Rather than an oppositional model of thought, Deleuze and Guattari attempted to show that the previous model did not provide the whole picture. This difference is perhaps easiest to understand if we consider the image of the tree in the context of a forest. In the forest there is no single truth, no singular cause and effect, no one 'true' tree. Rather, the forest is a single entity made up of numerous trees, or, numerous 'truths'. It is also impossible to posit one origin to a forest, and not simply because you cannot tell which tree came first. Any one tree is a product of an assemblage, of water, sunlight and soil, without which there would be no trees at all, regardless of whether a seed exists or not. To consider a tree in isolation, then, is erroneous, because everything is in fact the product of an assemblage with various different elements, and is not simply attributable to one cause. Everything is, in this sense, rhizomatic, and to think in the manner of the tree is only to use one aspect of the rhizome.

For Deleuze and Guattari, when thinking we should not always reduce things to 'one thing and its Others', one true way of thinking

and its competitors, but, rather, consider that every thing always contains many truths. For this reason they attempted to discard the hierarchical image of thought of the tree as somewhat illusory, and replace it with the horizontal image of the rhizome. Instead of tree, rhizome. Instead of one, one as many. Not one and its multiple Others, but a singular multiplicity. Like a forest, then, for Deleuze and Guattari the rhizome 'has neither beginning nor end, but always a middle (*milieu*) from which it grows and which it overspills'.[2]

Some concrete examples can help us understand the broader ramifications of the rhizome and rhizomatic ways of thinking. Deleuze and Guattari used the rhizome to describe living entities (pack animals such as rats and wolves) but also geographical entities such as burrows, 'in all of their functions of shelter, supply, movement, evasion and breakout'.[3] In the case of pack animals, the moving masses continually form and re-form a single shape, a fluid entity that is at once one and many. This is a clear example of a rhizome – a herd of wild horses, a wheeling flock of birds, etc. The idea of the burrow, however, provides a more interesting angle from which to consider the rhizome. Consider the guerrilla war of attrition that the Vietnamese Vietcong fought against the overwhelmingly superior technology of the US military in the 1960s and early 1970s. As part and parcel of this struggle they utilised an elaborate tunnel system which enabled them to evade the US military's land and air forces, store and move arms and supplies, build up numbers for ambushes and surprise attacks, and quickly disappear again once overwhelmed. The rhizome as burrow, then, is a way of describing an underground political movement, both literally, as in this case, and figuratively. As a further, figurative example, underground protest movements are now also able to gather strength and support among geographically disparate members using the rhizomatic networks enabled by the Internet. The rhizome, then, has many applications, one of which is in the political realm.

Deterritorialisation/reterritorialisation

At this stage a note of warning is needed. Whenever we explore thought (or, indeed, anything else) rhizomatically, there is always a deep ambiguity involved. The rhizome has the potential to produce great change, or, to use a word that Deleuze deployed in *A Thousand Plateaus*, to *deterritorialise*. There is also a complementary movement that is always involved, however, a force that attempts to recreate stability and order, to *reterritorialise*. As a shifting pattern (be it the rapidly shifting flocking of birds or the slow spread of a forest), the rhizome is constantly creating a new 'line of flight'[4] that enables it to deterritorialise. Along this line of flight it has the potential to move into (and onto) new territories. Lines of flight are created at the edge of the rhizomatic formation, where the multiplicity experiences an outside, and transforms and changes. At this border there is a double becoming that changes both the rhizome and that which it encounters (which is always, in fact, the edge of another rhizome). Deleuze and Guattari explain this process using the example of a wasp pollinating an orchid:

How could movements of deterritorialisation and processes of reterritorialisation not be relative, always connected, caught up in one another? The orchid deterritorialises by forming an image, a tracing of a wasp; but the wasp reterritorialises on that image. The wasp is nevertheless deterritorialised, becoming a piece in the orchid's reproductive apparatus. But it reterritorialises the orchid by transporting its pollen. Wasp and orchid, as heterogeneous elements, form a rhizome.[5]

This example illustrates that with every deterritorialisation there is an accompanying reterritorialisation. The orchid ceases to be entirely orchid as it encounters the wasp. It deterritorialises (a process of becoming wasp), but, as its pollen is moved elsewhere by the wasp, the orchid is also reterritorialised. The opposite is also true for the wasp. As Deleuze and Guattari have it, '[A] becoming-wasp of the orchid and a becoming-orchid of the wasp.

Each of these becomings brings about the deterritorialisation of one term and the reterritorialisation of the other.'[6] As with all such encounters there is an assemblage created, and a double becoming between both aspects of the assemblage.

What this example does not immediately show, however, is the power imbalance that usually accompanies such encounters. For a clearer example of the ambiguities that surround de- and reterritorialisation it is worth considering humanity's most violent and influential form of de- and reterritorialisation: colonisation. When the 'New World' of the Americas was first officially 'discovered' by Europeans (not to mention Australia, New Zealand and so on), their coastlines were mapped by the first sailors. As these lands were gradually occupied by European settlers a colonial mapping of these lands also took place. These acts of mapping were at once a deterritorialisation of European identities – as they explored new territories outside Europe – and a reterritorialisation, as they began to settle new lands. This process of mapping contained a mutual process of becoming, as the colonisers adapted to their new lands, and the new lands to their colonisers. Through contact with a new land and its peoples the values and practices of these European cultures were deterritorialised, transformed, and ultimately reterritorialised in a new form. Similarly, the native peoples of these lands (and, indeed, the lands themselves) were deterritorialised and reterritorialised into new forms due to the appearance of these strangers.

The history of colonialism is one of unequal reterritorialisation, however, in which the dominant European cultures – for all that they did adapt on encountering new lands and new peoples – ultimately came to impose their culture upon the New World. It would be euphemistic to suggest that war, massacre, genocide, slavery, concentration camps, taxes, land clearances, disease and numerous other such abuses were simply 'reterritorialisations'. While a dominant colonial power will often change as its rhizome comes into contact with another, the other, weaker rhizome is

often absorbed, or forcefully reterritorialised by its culture. Thus, although the rhizome provides a new way of thinking, due to this imbalance in the process of mutual becoming-other that is de- and reterritorialisation, the rhizome should not necessarily be celebrated as the answer to all problems encountered when thinking in the manner of the tree.

Rhizomes in context

Finally, it is worth considering the context from which the idea of the rhizome emerged. In May 1968 there was an enormous popular uprising throughout France, beginning with a mass student strike in Paris, which was soon joined by workers all over the country. Not long after this, in 1972, Deleuze and Guattari wrote their first book together, *Anti-Oedipus: Capitalism and schizophrenia*. *A Thousand Plateaus* was originally published as the sequel to *Anti-Oedipus*, and the idea of the rhizome is clearly a development of ideas found in this original text. *Anti-Oedipus* is a dense book that rails against psychoanalysis for attempting to 'cure' non-conforming desires by reducing them to the familial, Oedipal triangle of 'daddy–mummy–me'.[7] Deleuze and Guattari consider psychoanalysts as modern-day priests,[8] charged with placing the origin, or root, of all psychological issues in the bourgeois family home. Psychoanalysis, then, functions by perpetually imposing the image of thought of the tree. If you have a sexual 'problem', this is because you did not develop correctly as a child. You did not develop into a healthy tree because your roots were not given the proper nourishment as a sapling. In fact, in chapter 2 of *A Thousand Plateaus*, Deleuze and Guattari return to psychoanalysis to reiterate this point in relation to the idea of the rhizome, which they introduce in chapter 1.

In contrast to psychoanalysis, and perhaps as a consequence of experiencing the uprisings of 1968,[9] Deleuze and Guattari felt that humanity had more chance of developing if it looked less at the family as origin, and more at the rhizomatic patterns of everyday

life in which we are interact with others. Humans are pack animals, and, although society structures our activities through institutions that are hierarchical (that function as trees), there is always the possibility of a rhizomatic grass-roots (!) revolution emerging from the interaction of people. For this reason they preferred schizoanalysis to psychoanalysis, a practice of finding ourselves by exploring our identities as pack animals – or, rather, as a pack of animals. Instead of seeing the unconscious as a dark and forbidding place in which desire is buried, for Deleuze and Guattari the unconscious is a place of underground passageways or rhizomatic burrows through which desire moves like a guerrilla fighter, ready to spring up when we least expect it.

Chapter 1

Gaming in the labyrinth

David Martin-Jones

This chapter examines the video game as illustrative of the rhizome, and the problems of de- and reterritorialisation that occur when we try to understand the effect of games on gamers. It begins with an analysis of the way many video games are structured around a process of mapping that implies possible de- and reterritorialisations within the particular game world. It then explores some of the broader ways in which gamers are de- and reterritorialised during the process of playing. Although the academic study of the video game is a very recent phenomenon, numerous attempts have already been made to theorise what video games mean, and the effects they have on the people who use them. This section thus summarises many of these debates, noting their significance in terms of the concept of a possible rhizomatic gamer identity. Finally, the chapter concludes with an analysis of the first three versions of the controversial game *Grand Theft Auto* (1998–), as an example of the way gaming can be viewed as either a de- or reterritorialising of identity.

A brief history of video games

The history of the development of the video game is well known and well documented. Without going into any great detail, the first games were constructed in the 1950s and 1960s, and are usually considered to be Alexander Douglas's computerised noughts and crosses (also known as Tic-Tac-Toe) created at Cambridge University in 1952; William Higinbotham's very basic tennis game

(a precursor to *Pong*) designed as a visitor attraction for the Brookhaven National Laboratory in the United States (a government nuclear research facility) in 1958; and, most sophisticated of all, *Spacewar*, developed by Steve Russell and other researchers at the Massachusetts Institute of Technology (MIT) in 1962. In the 1970s video games began to be played in the home, with the Magnavox Odyssey, quickly followed by the Atari games console and now classic games such as *Pong, Space Invaders* and *Pac Man*. This period also saw the flourishing of video games in the arcade. The 1980s brought home computers such as the Sinclair Spectrum, and from Japan both Nintendo and SEGA emerged as major players in the global market for video games. Finally, in the 1990s and 2000s the home video game market really took off with the competition between the short-lived SEGA Dreamcast, the Sony Playstation, Microsoft's Xbox and the Nintendo GameCube.[1] Moreover, although there have been forms of online gaming since as early as 1969, this practice has also blossomed more recently with the global spread of the Internet.[2] MUD (multi-user dungeon) and, more recently, MMORPGs (massive multiplayer online role-playing games) now bring together thousands of gamers in virtual communities to interact with each other in the process of playing a game. This brief and rapid history has already seen one major boom and bust in the video games industry, during the 1980s, and, although video games are now a multi-million-dollar industry, at different times their inception and development have been variously due to the efforts of computer enthusiasts such as Russell and his colleagues at MIT, energetic entrepreneurs such as Ralph Baer of the military electronics company Sanders Associates, and Nolan Bushnell, the founder of Atari, as well as the university sector and the military as research environments.[3]

Correspondingly, although it is also still relatively young, the field of video game study is one of the most rapidly expanding of all academic disciplines. The major barrier that it faces is overcoming the prejudice that video games (a mass medium

associated with leisure time, and often with the 'wasting' of time in general) are somehow not worthy of study, no matter how popular they might be. This is a bias that Andreas Huyssen has described in a much broader context as forming part of the feminisation of mass culture that has occurred throughout modernity, and it can also be applied to the study of pulp literature, radio, film, television and so on.[4] Despite this barrier to its development, since the late 1990s the field of video game studies has produced numerous books and anthologies, and in 2001 the first online journal dedicated to video games, *Game Studies*.[5] As many of the people to write on the video game are gamers themselves, and due to the number of different games that exist, there are numerous takes on the effect the gaming experience has on the gamer. In the sections that follow I discuss these theories to see whether they suggest that a de- or reterritorialisation of the gamer is possible, as part of a larger discussion of the rhizomatic potential of the video game.

Pac Man : mapping space in the video game

In *Cinema 2* (1985), Deleuze notes that certain European films that emerged after World War II displayed a view of time similar to that of the labyrinthine model of time found in the writings of twentieth-century Argentine author Jorge Luis Borges.[6] In chapter 5, this type of cinematic construction of time is discussed in more detail. In relation to computer games this concept is also useful. The rhizome can also be considered a labyrinth, although this must be understood as an ever-expanding labyrinth without restrictive points of access or defined centre. As we saw in the introduction to Part One, a rhizome grows from its middle. As so much gaming is concerned with the traversing, investigation, mapping and controlling of space, this idea of the rhizome as labyrinth can also be applied to video games.

Consider a very early game such as *Pac Man*. The space of the game is laid out as a single level, on a single screen, seen from an

aerial point of view. This space is constructed rather like a maze, or simple labyrinth, with partitioning walls and channels along which the Pac Man can run. This space is not a rhizome per se, as the layout is that of a fixed space that does not contain the possibility of change due to the actions of the gamer. It is not possible, say, to build a new wall. Nonetheless, the gamer's actions controlling the Pac Man can be considered as a reterritorialising of this space. The Pac Man can be considered an explorer who moves through the labyrinth, consuming everything in his way – from the ubiquitous pills to the cherries, oranges, strawberries, apples, grapes, bananas and other fruits that appear as bonuses, and even to the blue ghosts that appear when the Pac Man becomes supercharged. This type of reading of the game is in line with that of several commentators who consider the act of gaming to be rather like that of colonisation. As James Newman summarises in *Videogames*:

Typically, videogames create 'worlds', 'lands', or 'environments' for players to explore, traverse, conquer or even dynamically manipulate and transform in some cases...sites...in which play is at least partly an act of colonization and the enactment of transformations upon the space.[7]

Similarly, Barry Atkins in *More than a Game* (2003) discusses the colonial undercurrents of recent games such as *Tomb Raider*, in which the aristocrat Lara Croft journeys through foreign lands using her 'superior technology' to dish out violence against mute representatives of the indigenous population, whose artefacts she steals for herself.[8] In respect of this type of reading, Pac Man appears to be the ultimate coloniser, someone whose only goal in life is to consume as much as possible, laying to waste the ground he covers in the process.

As we saw in the introduction to this part, when space is reterritorialised in this way, as a colonising action, there is always an unequal power bias involved. Thus, when viewed in this light,

video games appear extremely conservative, at least at the level of content. There is a chink of light, however, here for people who do not want to simply damn all video games as being as conservative as their 'stories' often are. Another way of viewing *Pac Man* is that it represents a deterritorialising of space. As the above quote from Newman shows, there is some ambiguity over whether playing a game is always an act of colonisation, or whether it might be better understood as an attempt to 'dynamically manipulate and transform' space. Admittedly, the Pac Man cannot control the shape of the space he moves within, but his movements themselves can be said to transform it. While mapping the enclosed space in which he is contained, the Pac Man must avoid being stopped (literally reterritorialised) by the ghosts that control the space. If he is caught at any point then he is killed. In many respects, then, *Pac Man* might be considered less a game about colonisation than it is a game about imprisonment and escape. Certainly, the sirens that sound as the Pac Man nears escape suggest as much.

As the Pac Man eats each of the little pills he creates a cleared channel, and the more channels he clears the closer he is to escaping from the maze. In fact, the only way for the Pac Man to deterritorialise – to literally move on from this space – is to continually move in different directions, hide, avoid the ghosts as much as possible, and use the supercharge to ambush them as they converge on him. In this respect, *Pac Man* can be considered less a representation of the process of colonisation than a representation of the process of perpetual evasion and deterritorialised movement deployed in order to combat colonisation. To return to our example from the introduction to this part, the movements of the Pac Man are a little like that of the Vietcong in their tunnels. His constant shifting of direction traces the trajectory of hit-and-run guerrilla warfare. Thus, although the static space through which the Pac Man moves is not rhizomatic, his movements *are* rhizomatic, because they deterritorialise and transform the space through which he moves. In addition to the textual level, though, what

potential is there for de- or reterritorialisation of the gamer's identity while playing video games?

The gaming experience: de- and reterritorialisations

Several theories exist that view the gaming process as offering the potential for the gamer to deterritorialise his or her identity. Most obviously, gaming is a form of play, an action in which people traditionally 'lose themselves'. When playing a game the gamer usually experiences the game world through an avatar. An avatar is a character in the game world that stands in for the gamer. Some classic examples of avatars would include Pac Man (and, indeed, Ms Pac Man), or Mario from *Donkey Kong* and the *Super Mario* games. More recent examples would include third-person shooters, such as Lara Croft in *Tomb Raider* and Solid Snake in *Metal Gear Solid*, characters in first-person shooters, such as the anonymous space marine in *Doom*, or Gordon Freeman in *Half-Life*, the various family members that gamers give their own names to in *The Sims*, and so on. At its most basic level, then, the presence of the avatar means that, once immersed in a video game, the gamer can literally become another person for a while. Moreover, in first- and third-person shooters it is not uncommon for a map indent also to appear in the corner of the screen, requiring the gamer to maintain a rather sophisticated visual overview of the game world, noting the position of his/her avatar on the main screen *and* on the map in the corner. Here the gamer is further deterritorialised from his/her own identity, controlling an avatar that is at once visibly 'here' and 'there', at once both 'I' and 'he/she'.

Moreover, each time we play a video game the experience is different. As we learn to play games more and more effectively we transform ourselves, the development of the avatar's progress within the game mirroring the improvement of our skills as gamers – improving our knowledge and expertise in the process. This could be considered a form of deterritorialisation of the gamer that is built into the computer game. Gonzalo Frasca, for

instance, argues that some games are less interested in providing the gamer with a set goal to reach (as first- and third-person shooters generally do) than with enabling the gamer to explore multiple creative possibilities. Frasca cites *SimCity* as an example of this type, as it has the potential to be noticeably different every time the gamer constructs a new city.[9] In such games there is an open-ended potential for the gamer to deterritorialise his/her identity. This potential is multiplied again in multiplayer games such as *Quake, The Thing* and *Half-Life: Counter-Strike,* where there are more possibilities for new experiences each time the game is played, because different players will react differently both to events in the game world and to the presence of each other.

The most positive take on this form of immersion is that it has the potential to liberate gamers from their usual identity. It enables them to act in ways they never would normally in reality. Viewed in this way, video games are social safety valves. They let people experiment with their identities, imagine ideal identities, or simply let off steam by breaking rules and destroying things they would usually have to respect. On the other hand, some critics of video games see this as a dangerous illusion that can lead to serious antisocial behaviour. More to the point, the idea that gamers deterritorialise their identity and become other people when immersed in the game is easily criticised. For many people the experience may feel no different from that of playing with a doll or an action figure as a child. Why should we necessarily believe that, when gaming, we have left our own bodies and *become* Pac Man, Mario, Lara Croft or Solid Snake? After all, although frustrating, it is unusual to feel physical pain when Pac Man is eaten by Pinky the little pink ghost.

MMORPGs, mods and the rhizome

A more sophisticated way of considering the way games enable gamers to deterritorialise their identities is through the creation of virtual gaming communities.[10] Indeed, drawing on Deleuze and

Guattari's *A Thousand Plateaus*, Miroslaw Filiciak has noted that gaming communities can enable rhizomatic identities to emerge.[11] One example of this type of rhizomatic interaction would be a LAN party, where gamers congregate to interact virtually over a local area network, or LAN. For the period of the game these gamers form a community, sharing a set of rules established by the game that is played. After the game the gamers disperse again, their temporary group identity illustrating how a rhizome is formed by a shifting mass of deterritorialised individuals who meet and temporarily reterritorialise, only to disperse (deterritorialise) once again.[12]

Further examples of this type of rhizome are found in MMORPGs such as *EverQuest*, *Star Wars Galaxies*, *WarCraft* and *Ultima Online*. When playing these games the gamers may never physically meet, but there may be thousands of online users involved simultaneously, interacting in the same virtual environment. Each user creates his/her own avatar or avatars, which can be considered virtual versions of the user's self, through which they can experiment with their identity. Filiciak states:

In the case of MMORPGs, there is no need for strict diets, exhausting exercise programmes, or cosmetic surgeries – a dozen or so mouse clicks is enough to adapt one's 'self' to expectations. Thus, we have an opportunity to painlessly manipulate our identity...[13]

Through interaction with other online users, users in these virtual gaming communities are then able to experiment by using these other, virtual selves to interact with others. This experimentation with identity can be understood as deterritorialising in numerous ways, but, just as one simple example, let us consider gendered identity. Although a male gamer may only try on the identity of a virtual female character for a few hours (or vice versa), there is no doubting that in some ways this experience becomes a part of his 'real-life' experience, a part of his identity. If any proof of this were needed, *EverQuest* alone is

reported to have 'generated a (real-world) economy comparable to that of a medium-sized country', with one-third of its adult users spending longer in the game than they do in work.[14]

In addition to this deterritorialisation of the user's or gamer's self, some video games enable the gamer to adapt or construct his/her own game environment, to create modifications, or 'mods'. Above and beyond the choosing or adapting of 'skins' for avatars (turning the avatar into a character of the gamer's choice), in certain games the gamer has the option of creating his/her own characters and levels. This potential for video games to enable gamers to adapt their game world was apparent once *Doom*'s source code was released to the general public, allowing its users to adapt the game environment.[15] Nowadays games such as *Quake* and *Half-Life* similarly allow the gamer to create his/her own mods.[16] In these instances, rather than characters exploring an environment of the game designer's invention, the gamer is able (to a certain extent) to play God. This practice ensures that the gamer – rather than constantly running for his/her life in order to deterritorialise the space of the game world (like Pac Man or Lara Croft) – can deterritorialise the very maze in which he/she runs. Now the game environment itself becomes an adaptable rhizome. Gamers effectively become producers of the game, not just because they interact with the game world (design and build a city, kill the zombies, etc.) and therefore 'design' the narrative of their game experience, but also because they can, quite literally, help to design the world in which they play.[17] Here the space of the game becomes rhizomatic. If we return to the example of *Pac Man* and its correlation with guerrilla warfare, it is as though the gamer – rather like the Vietcong – is now able to dig his/her own tunnels, to increase the possibilities of surprising his/her opponents, and of influencing the outcome of the game.

However, it is always worth remembering that, even in MMORPGs – where there seem to be almost infinite possibilities for rhizomes to develop – there is a strong reterritorialising

influence exerted by the virtual gaming community. As Sue Morris documents, in multiplayer games social rules soon develop among the gamers involved: 'Certain actions are considered to be unsporting or forms of cheating even though they are well within the possibilities of the game.'[18] Where such norms appear it is evident that the rhizomatic possibilities offered by this particular grouping of gamers is in the process of reterritorialising.

Video games are bad?

One question arises from this analysis of the potential for identity deterritorialisation offered by the video game. If video games offer so many possibilities for potentially liberating identity exploration, why are they regarded with suspicion by the general public and the media? The most obvious answer is that no one can really explain the allure of video game violence, a violence in which the gamer willingly participates. In 2002 a lawsuit filed against the manufacturers of video games by parents of schoolchildren killed in the Columbine massacre in 1999 was dismissed. Many people accordingly hold the view that video games *in isolation* could not cause a massacre such as Columbine.[19] Even so, the debate continues. The question that Deleuze's idea of the rhizome enables us to ask of this debate is: does this violence enable a deterritorialisation of the gamer's identity, or is it somehow reterritorialising?

Furthermore, video games are also regarded with suspicion by some theorists, but for a very different reason. To consider the extent to which video games also reterritorialise the gamer we must consider the related question of ideology – or, put another way, the politics of the video game. Here again, Deleuze and Guattari's concept of the rhizome is extremely helpful.

For some critics, video games can be loosely interpreted as practice for capitalism. They express the ideology of market capitalism, which is transmitted to the psyche of the gamer under the cover of a seemingly innocent game. Leaving aside the fact that

very few games are actually innocent, *Pac Man* again offers a clear example of this working of ideology. In *Trigger Happy*, Steven Poole notes how the Pac Man is the 'pure consumer', only happy when he is eating, and never finished eating.[20] In short, he is a representative of consumer capitalism, and the gamer who controls him is simply performing the logic of consumption. Consume and you will be rewarded with points (consume and you will be paid), consume and you will be temporarily freed… and then returned to the same environment in order to consume some more. Indeed, *Pac Man* is far from the only such example, as very many video games revolve around completing jobs or tasks and collecting points as a reward.

Thus there is a general feeling that video games are dangerous, either because they are too violent, or because they are so much 'capitalist brainwashing'.[21] Combining these two approaches, in some cases they are regarded with suspicion because they use violence as part of this brainwashing. This feeling is exacerbated by the development and use of video games by the military. Not only were the first games developed by workers in the military sector (such as Higinbotham and Baer), but so too has military investment in arcade technology – for instance, on behalf of Lockheed-Martin – advanced its development.[22] The very existence of the flight simulator as both video game and tool for combat training reinforces awareness of the link between video games and the dominance of the military–industrial complex under market capitalism.

For this reason, Poole initially begins by celebrating the free circulation of the original source code for *Spacewar*, calling it a 'benign virus… eating up time all over the world on government, military and scientific mainframes'.[23] Once such a commodity has been appropriated by major corporations and has become a saleable product, however, this idea that it is somehow a benign virus is often replaced with the notion that it has been reterritorialised and is a commodity that serves the needs of

capitalism. We might be forgiven for wondering how such a product can be potentially deterritorialising for its consumer. Surely it must express a very reterritorialising agenda?

In answer to these questions, the fact is that whether video games are viewed as de- or reterritorialising is a matter of perspective. For every argument that the video game is reterritorialising there is a counter-argument that the use of the game is potentially deterritorialising. As Poole also notes of *Pac Man*, its popularity with female gamers may have been due to its unbridled celebration of consumption in a very literal sense. In a world where there is peer pressure to remain slim, *Pac Man* offers an opportunity for its users to embrace virtual eating. Far from a subliminal trick encouraging people to be more avid consumers (an ideological reterritorialisation of the gamer), in this instance *Pac Man* offers liberation from the pressures of the cult of the ideal slim body.[24] Research into the effect of video games on the gamer has failed to provide conclusive proof either way, with various writers in the 1980s concluding that video games either correlated with aggression among users, or worked to calm them.[25] Thus, while Derek A. Burrill convincingly argues (in 2002) that video games based on James Bond films inscribe a certain type of masculine behaviour on the gamer characterised by a 'stealthy, violent sexism',[26] Mia Consalvo just as convincingly argues (in 2003) that *The Sims* offers the gamer numerous possibilities for trying out new gendered and sexual identities.[27] The final section of this chapter examines how this ambiguity is evident in the first three versions of *Grand Theft Auto*.

Grand Theft Auto

The original *Grand Theft Auto* (hereafter *GTA*) is a crime spree game, in which the gamer has an aerial view of the activities of his/her avatar as he/she travels around the maze-like roads of 'Liberty City'. The avatar is guided by an arrow that leads him/her to phone booths. On answering the phone, mob jobs are

outlined in text on the screen. The arrow then leads to the job. Once the job is completed (often the removal or retrieval of a vehicle) another job becomes available, and so on. The purpose of the game is to complete the jobs, and in order to do so the gamer is required to steal cars, motorbikes, buses, or trucks, develop some proficiency in driving these different vehicles, and avoid the police. On route to jobs he/she is also able to kill passers by, gangsters or police, either with his/her vehicle or the various weapons left in crates scattered about the city. *Grand Theft Auto 2 (GTA2)* was somewhat similar, except that the game environment was more deadly due to the controlling presence of several warring gangs. In *GTA2* it is possible to get mugged or killed simply by standing still for too long in the wrong area, the traffic is more aggressive generally, and after capture the police unceremoniously dump the avatar on the road from a moving squad car.

The aerial view of the avatar in the first two versions of *GTA* provides the gamer with a somewhat similar experience to that of *Pac Man*, only on this occasion there is only ever a small section of the city visible at any one time. *GTA* therefore contains more sudden surprises, as the police may arrive on screen from any direction. It is also more difficult always to know where you are going. The arrow points in the general direction of the job, but the roads themselves may wind away from the direction of the arrow, making the inexperienced gamer take a circuitous route. More experienced gamers, however, will have explored short cuts across the city's various parks and half-completed bridges, and so will get there more quickly. In terms of mapping, then, the experience of playing *GTA* is one of constant exploration. As with *Pac Man*, although this could be considered to be in line with the notion that the gamer colonises the space of the game world, the constant uncertainty over direction, the danger of imminent capture and the perpetual unfolding of off-screen space all ensure that the gaming experience is more one of deterritorialisation than of reterritorialisation. As each of the games also includes a paper

fold-out map of the city, should a gamer wish to learn the space in a more calculated manner this is also possible, but the experience of gaming is in effect one of exploration, providing therefore the usual ambiguity as to how capable the gamer is of reterritorialising (colonising) the space, and how much he/she must manoeuvre (deterritorialise) to avoid being reterritorialised (captured or killed) by the game.

In terms of ideology, in spite of the emphasis on criminality, *GTA* initially appears to conform exactly to the idea that video games are practice for capitalism. Most obviously, the game is structured around a series of jobs completed for a points reward. Admittedly, these are all criminal activities, but, even so, the argument remains valid. After all, who would buy a game in which the jobs the gamer had to complete were photocopying or filing? Moreover, tapping into ideas of individual freedom prevalent both in the United States and more generally under market capitalism, *GTA* is built upon the premise that you are 'free' (this is Liberty City, after all) to steal a car if you so desire. In fact, as moving around the city without wheels is so time-consuming that it often negates any pleasures the game offers, stealing a car is practically essential. Here the game expresses the ideology of automobile freedom on which the United States built its Fordist economy in the early twentieth century. Finally, although the game seems to celebrate criminal activity, as the gamer is perpetually at risk of imprisonment by the police, *GTA* actually shows how difficult it is to make crime pay.

The above notwithstanding, there is debate as to whether *GTA*, and the public controversy surrounding it, necessarily imply that it is reterritorialising of the identity of the gamer. Taking the view that the violence of the game leads to violence in the gamer, the British Police Federation condemned *GTA* as 'sick, deluded and beneath contempt'. Surprisingly, however, the New York Police Department took the opposite view of *GTA2*, stating that they would rather have such criminal activity take place in a game than

on the streets.[28] Contrary to the idea that game violence breeds real violence, the position of the New York Police expresses the notion that the game provides a safety valve mechanism that allows people to lose themselves (deterritorialise) for a while in a new identity, getting feelings of repressed violence out of their system.

More importantly, perhaps, all the *GTA* games, and especially *Grand Theft Auto 3* (*GTA3*), enable further deterritorialisation of the gamer from the goal-oriented ideology of the marketplace. By the time of *GTA3* (2002) the graphics had changed considerably, and, rather than an aerial view of the city, the game is constructed as a 3D environment with a third-person avatar seen from eye level, as in games such as *Tomb Raider*. The choice of vehicles to steal has risen to include SUVs, station wagons and even boats, and now cut scenes (small sections of movie-like footage) are used to introduce mob characters and the jobs they offer. Along with this revamping of the graphics come even greater freedoms for gamers, who can simply ignore the tasks they have been set, and explore the city. Gamers can abandon cars altogether, take the train or the subway, or simply enjoy exploring the city on foot. In this way, not only can a jog through the park be rewarding in terms of the graphics experienced (something it would have been fairly difficult to argue of *GTA* or *GTA2*), but so too only in this way can many hidden packages and weapons be found. The increased possibilities for activities beyond the goal-oriented completing of tasks has led one commentator to compare *GTA3* with a flight simulator, where the pleasure was in experimenting in a simulated environment, rather than successfully completing the game.[29] Admittedly, this experimentation can involve such activities as carjacking, causing car crashes, mugging, running down, shooting or violently beating passers-by to death, and stealing. The point remains that the *GTA* games are concerned with opening up a space for experimentation, an arena that is potentially deterritorialising of the gamer's identity.

In terms of offering a deterritorialised identity to the gamer, *GTA3* also goes much further than its predecessors in certain other respects. It contains a 'radar', a small map inset in the bottom left-hand corner of the screen, enabling gamers to chart their position in the city as both big-screen and map indent. Gamers experience Liberty City from both 'here' and 'there', as both 'I' and 'them'. This schizophrenic experience of being both present in the game world and able to watch yourself from afar is enhanced by the various different camera angles that can be chosen from which to view the avatar (including the traditional aerial view of the first two games but also the avatar's first-person point of view), and gamers' ability to change radio stations in the cars, which also changes the soundtrack to the game they are playing. Clearly, *GTA3* aims to give gamers the opportunity to blur the boundary between 'real-life' experience and the game.

Like *Pac Man*, then, the *GTA* games are all confined within an apparently labyrinthine space, but the limits to the city are clearly defined. The one thing the avatar cannot do is swim away from Liberty City, so, as in *Pac Man*, there is no escape from its imprisoning labyrinth. Thus the mapping of the city's streets in the process of playing the game may appear to represent a colonial conquest of space (reterritorialisation), but from another perspective the game is forever creating a rhizome, forever deterritorialising as the avatar moves into unknown territory. Moreover, beyond the level of the game world itself, gamers have the potential to deterritorialise their usual identity as they explore the possibilities of a criminal life that is not normally available to them, or simply ignore crime and enjoy travelling around the city, creating a deterritorialising rhizome as they do so.

Chapter 2

Virtual structures of the Internet

Damian Sutton

It is perhaps no accident that the mid-1990s resurgence in Deleuzian thinking and debate coincided with the first few years of the Internet boom. By the time that the Internet had passed from being a wholly academic or military affair to a commercial and cultural space beyond the ivory or stone towers, terms such as 'rhizome' were being used not only as a theorem but as a rallying cry. Now it can sometimes seem difficult to move intellectually because of the sheer agglomeration of Deleuzian commentary on the Internet. To think of the Internet as only a carrier of Deleuzian thought, however, is to misunderstand the influence that 'rhizomatic' or 'rhizomorphic' thinking had on the Internet's very ethos – an influence that continues to be felt even as we enter the days of Web 2.0, an ethically inspired attempt to wrest control of the ether away from corporations and conglomerates, and leave it in the hands of the people. The rhizome, as a theorem, a way of moving, and a way of connecting, allows us to understand not only some of the politics of the Internet, but also the laws of connection and movement that give those politics shape and colour.

The simplest picture we can draw of Internet politics is one of 'Jeffersonian democracy', named after the United States' third president, a champion of local, individual and state rights over big government and federalism. At the heart of this was the individual's right to make money in a free market (that is, an individual who was white, male and who owned land). The idea is a curious mixture of politics, and not wholly suitable for today's

political liberalism, which sees the championing of the free market and the right to make money as something that multinational corporations do. Nevertheless, the comparison is strangely easy to draw between the expansion of the New World and the settling of the wide open spaces of the Internet: individuals in a new terrain, staking out their land, their place, battling against centralised government (especially when it is represented by taxes or the forces of order), speaking a language of liberty and social equality, yet ready to claim their right to make a profit. And yet we need a strange comparison because of the strange politics of the Internet that exists, an intensely charged political space in which the rights of free speech and free will are championed by commentators on all sides, provided they have money to invest in the equipment. We also need a strange comparison because of the ways in which the Internet displays that most strange of characteristics in the rhizome, the capacity for deterritorialisation to become reterritorialisation, for open, non-linear, deconstructions of the capitalist hierarchy to be turned into an obscene imitation of the very thing that it aims to decompose. The Internet is significant not simply because it has pervaded our lives to such an extent, but because in so doing it is a socially structured space that reflects the same formations we walk through and drive through in real life, the virtual counterparts of the shopping and leisure centres, financial centres, cafeterias, lecture theatres and libraries. New social areas of interaction, such as photo- and video-sharing sites such as *YouTube*, are incorporeal or virtual spaces hosting the same kinds of social interaction as do the dorm room, TV room, book club or film club.

The immanent Internet

The best place to start is by describing what the Internet is made of, and the Internet is made of immanence.

Well, almost. Ordinarily, we can't see immanence, we can only suppose that it's there. All we ever see is the shape that it leaves

in the matter around us. The Internet helps here because we can easily understand that it has form and shape that is substantially different from the matter with which we encounter it. If you were to read this book online, you would be able to turn pages (by scrolling or clicking), read the lines, even perhaps mark the 'page', but you would still not be interacting with the 'matter' of the book in any way. You would be using a mouse or keyboard. You would have the idea of the book in mind, however, and that idea would have a shape that you give it or perhaps the shape that is suggested by the computer (images of pages, for instance). Where these two shapes intersect is the closest thing we'll get to a physical manifestation of immanence – the plane of immanence. It is the plane, the intersection or coalescence of the material and immaterial, that matters.

At first glance, we can understand that we have a general sense that everything we see around us has form or shape, from the material world to larger sets of forces and pressures. For instance, we can easily observe that the lecture hall we enter has rows of seats, a lectern, a data projector, a microphone, that these are in place for a reason: all the seats, for instance, are banked to face the lectern; the lectern may even be on a dais or platform. We might also be aware that this organisation of the material corresponds to larger, more intangible forces and organisation: the education system, its theories and methods, the wealth or poverty of the college and so on. These levels of organisation operate together, and are mutually dependent. To peel them away might destroy other layers. In this sense, the layers of organisation are like strata, in that they are both integral components, and fault lines, of the larger structure.

The whole, the larger substance, is what Deleuze and Guattari call the 'plane of organisation', the material intersection of all forms, subjects, organs and functions. Deleuze and Guattari are doing more than simply describing social or cultural formations in a novel manner, however. Instead, they want to ask: what happens

when you remove all form, all the strata? Is there anything left? The answer is 'yes', since there would be forces and energies that remain, that never go away: 'Pure relations of speed and slowness between particles imply movements of deterritorialisation, just as pure effects imply an enterprise of desubjectification.'[1] This is the plane of consistency, the plane of immanence. So, while we might never be able to remove all form, what Deleuze and Guattari are suggesting is that to dismantle part of it – to peel away a stratum, to reduce a function – is to let some of those forces loose, to begin the process of deterritorialisation. For Deleuze and Guattari, to think immanence is the greatest challenge; that is why it is the ultimate task of the philosopher: 'We will say that *THE* plane of immanence is, at the same time, that which must be thought but which cannot be thought. It is the nonthought within thought.'[2] Even after this there is a greater calling, however. A detached observer might watch for the plane to break free, might be able to talk about its existence, but the real task is to provoke the process of deterritorialisation in others. 'Perhaps this is the supreme act of philosophy: not so much to think THE plane of immanence as to show it is there.'[3]

So the Internet immediately offers itself as something within which to glimpse immanence. It is a virtual reflection of the real world, but one that both mimics and is clearly different from the real spaces it reflects. The Internet is less a series of objects and spaces than a series of movements between them. This movement can be in 'logical' linear sequence – from bank account to online shop – or it can take new pathways linked only by the random thoughts of the surfer. Indeed, movement through the Internet can seem separate from the user, in that the user rides the movement, rides the wave: hence 'to surf'. The Internet therefore already begins to peel away the stratum that forms society, since that stratum relies on clear connections of objects and spaces, connected broken and reconnected in new formations. No matter how many new connections are made, whatever formation,

what is constant is the movement, no matter how quick or how slow.

The real boom time for the Internet came in the mid-1990s, when it flowered from a largely academic and business medium into one of social interaction. The Internet started as a military application, ARPANET, designed in the 1960s as a network of computers that would survive even if one or more were destroyed, as in a nuclear attack. By 1989 the population of Internet users in the United States, its largest community, stood at about 400,000, mostly academic and research users. This was the year that the first commercial Internet service providers commenced operation, some of them already existing companies such as CompuServe. By 1994 CompuServe, America Online and Prodigy shared eight million subscribers in the United States.[4] This period of growth was further accelerated in the late 1990s by the falling price of personal computers (PCs). This included the widespread manufacture of components for users to build PCs at home, as well as the introduction of models such as the bubble-shaped Apple iMac G3 in 1998.

The Internet thus quickly became interesting as a social medium, to the amateur user as much as the scholar. There are few weblogs that do not, at some stage, reflect upon the very ability of the Internet to traffic their thoughts and ideas across the world, producing the exact same data in different countries and contexts seemingly independent of the equipment it is seen on. Even now it is often the medium of the Internet that is discussed, rather than the content per se, and, in discussions (as we have seen) about MMORPGs such as *Ultima Online* and *Second Life*, it is not so much the users or the game itself that is discussed but the difference between the life of one and the life of the other. What is discussed is the deterritorialisation immanent in the difference between one's home in real life and one's home online.

Some of the first studies of the Internet, such as those by Arturo Escobar, recognised this as 'technosociality' – sociocultural construction according to technology.[5] Life begins to move to new

beats and rhythms, to a point of irreversibility, when it is realised that there is no going back. Furthermore, the beat of the Internet drum was marking time for the politics of the media, which, for many, had until then been confined to the pages of academic studies or liberal and radical newspapers. The Internet's technosociality is not connection (it rides on the back of the telephone network), even though the study of the Internet is turning toward this. Its technosociality is not information (it operates like any other database, only on a vast scale). The Internet's technosociality is in its flows of information and the control of those flows; hence the politics of the hacker culture that grew up in those first few years of the Internet's boom – the same few years of that tremendous resurgence in interest in Deleuze and Guattari. This was a politics of deterritorialisation, for which the cry was 'Information wants to be free', and in which it was realised that it was ideas, rather than objects, that would be the goods of commerce. Not only that, but a free market of ideas would enable 'truth in reality', as Tim Jordan observes: a strange combination of *laissez-faire* economy and left-wing media activism.[6]

A geology of hacktivism

'Hacktivism', as an oppositional strategy of political resistance to state control or global corporatism, is made of an older stone, one that has been recut or carved again. This is the hard, sandy stone of Marxism, formed in the writings of Karl Marx as a sediment that would be revealed (when the tide of Communism had begun to roll back from left-wing intellectual writings) in some of the best media analysis to emerge from the late 1960s and early 1970s. The sandstone is now weathered and eroded, repointed by new media theory. If we look at some of its most vivid thinkers, however, then the stone, like the blondest sandstone, still has luxurious and colourful strata.

One key thinker from that early period was Hans Magnus Enzensberger, who, like others, saw that the telecommunications

medium was linear and centralised, that it was a one-way flow of information from the centre to the periphery. Viewers, listeners and readers were reliant upon this service, alienated or estranged from the source and from each other, since this one-way communication precluded contact with the community in any meaningful, mediated way: 'The distinctions between receivers and transmitters reflects the social division of labour into producers and consumers.'[7] Of course, this notion of alienation or estrangement was profoundly influenced by Marx and his identification of estranged or alienated labour. In mass manufacturing, workers are far removed from the final object of production, in which they have only a contributing hand. They are paid directly for their labour, and the commodity value of the product is far removed from them and their own (which is only the direct value of their work, for which, as labourers, they are practically interchangeable).

What excited Enzensberger at the time, however, was the burgeoning growth of video and other media technologies, such as wireless radio, for instance, that were potentially available to new communities. What he saw was the possibility of media control wrested from centralised, state-owned organisations and corporations and put into the hands of workers' communities, because this technology could be situated in the home or the workplace and used to broadcast *across* the pathways of social interaction. This would be a social formation used to transmit news, which normally comes from the authoritarian centre, that would have new agency because it would be free of state bias. The idea of video technology within the home, expressed by Enzensberger in 1970, still carries vital relevance to new models of news and information services. He imagines

(n)etworklike communications models built on the principle of reversibility of circuits … a mass newspaper, written and distributed by its readers, a video network of politically active groups.[8]

The contemporary realisation of this kind of network can be seen in collaborative news networks such as *Indymedia*, and even in the principle of wiki and the development of *Wikipedia*. Where *Indymedia* is a news service that is consciously oppositional, its real political power is in the connections it creates between local, amateur news gatherers that would not have been created by normal, centralised, broadcast news coverage by television and radio corporations. This is a public voice created by shared ideas and the usability of the technology, rather than the combined reception of the same message. Indeed, what can often happen is that political issues are raised on a global scale because of the connections, rather than shared political ideals. This is reflected in the growth of *Wikipedia*, an online encyclopaedia that is created by the contributions of users, and which eschews the clearly defined 'authoritative' voices of academia or commerce, for instance, which are seen to reflect centralised and dry accounts of the world, its societies and histories. Instead, contributors come from the body of users, often with no recognised authority (indeed, it is possible to be virtually anonymous), and the shared knowledge can be constantly edited by others. Thus the knowledge deposited for reference in *Wikipedia*, which often tops any online search for information on a given topic, is created through contestation and debate. The veracity of this knowledge is often at stake, and pages devoted to controversial subjects such as politicians and political issues, celebrities, and even sports teams, often have a large discussion forum and a long history of editing and counter-editing. It is even possible to edit one's own entry, and there is no guarantee that any entry is written by an authoritative contributor or edited by a genuine peer. *Wikipedia* therefore balances the weakness of inexactitude and inaccuracy against the powerful connections it makes between users and the ability it has to become, through a genuine notion of *common sense*, the authoritative voice on a subject.

Websites such as *Indymedia* and *Wikipedia* can therefore be seen as powerful agents for deterritorialisation, destabilising the

social forces of the state, which are invested as much in cultural formations as they are in the government, or law and order. The connections are no longer made between the centre and a disparate community of isolated users, but across users and between each other, and the 'centre' (the news corporations, for example, on the lookout for grass-roots news) is left following in the footsteps of a new, emancipated population.

Nonetheless, Enzensberger's enthusiasm for the media as a technology of emancipation was couched within an important warning against the ever more powerful culture industry, which seeks to create new users, viewers and participants who will continue to consume. Most importantly, it will look for any way to do this, and the very means of resistance are a prize target. Much of the content of Enzensberger's essays echoes the work of his contemporaries, particularly, perhaps, in this respect the work of Louis Althusser, who wrote of how the state apparatuses of repression, such as law and order, are joined by ideological apparatuses such as the school, the Church or even the family. These are apparatuses whose role is to reproduce 'the relations of production, i.e. of capitalist relations of exploitation'.[9] Effectively, we as subjects – as learners, users, viewers, consumers – are called into being by the systems within which we grow up, and which give us our ideology. No matter how independent we think we are, no matter how much we resist what we see as the cultural mainstream, we will eventually become a part of it. We will eventually become good little capitalists, because even the means of resistance involves consumption.

What does this mean for Enzensberger? First, he saw that it was too easy for new users to become detached from culture, or in a nihilistic fashion become reduced to 'isolated tinkering'.[10] Such users might speak out against consumerism or state power, but eventually their anger dissipates or is turned inwards. We can see this in websites such as Charlie Brooker's *TV Go Home* (www.tvgo home.com), which introduced British culture to his sharp criticism

of the media economy. Real and fictional characters were developed over a series of spoof pages from the BBC's television guide the *Radio Times*, which placed them in odd juxtaposition, lampooning celebrity culture and its trivialisation of political and social issues. This included the fictional character of Nathan Barley, who eventually became the subject of his own television series. Ironically, however, Brooker's own trajectory with *TV Go Home* was predicted in some of the acid attacks in the Nathan Barley column on the ways in which media creatives are constantly trying to capture the contemporary mood or zeitgeist, often with the latest technology, in order to market it back to the mainstream:

Playing table football in a Hoxton juice bar, Nathan Barley and three near-lookalikes decked out in regulation Carhartt uniforms excitedly discuss their plans for a five-minute RealPlayer comedy sketch destined for an absurdly over-designed online entertainment 'portal' run by one of their own schoolfriends, who has commissioned them to deliver six comedic 'webisodes' despite the fact that none of them can write, perform, or be trusted to deliver the goods on time, and that even the fastest and smoothest of RealPlayer video streams is basically fucking unwatchable.[11]

The fact that streaming video and 'webisodes' later became a major part of Internet media content for businesses and amateurs alike is perhaps also illustrative of Enzensberger's second concern: that capital recognises the power of new technologies and the attractiveness of cultural resistance, but 'only so as to trap them and rob them of their explosive force'.[12] New cultural formations created and enhanced by new technologies are not only useful in their attractiveness to youth markets, but any effectiveness can be dissipated as they are made more mainstream and a bigger part of wider consumer culture. Businesses, especially those appealing to young people with disposable income, are constantly on the lookout for new avenues for marketing.

For example, in 2001 a new type of graffiti began to appear in the United Kingdom on electric junction boxes, rubbish bins and boarded- up shops: a black stencilled image of a baby's face, tightly cropped in a four-inch square. The appearance of this image immediately echoed the already widespread images of André the Giant, the French wrestler. He has become something of a poster boy of cultural resistance as the face of the 'Obey Giant' street art campaign (www.obeygiant.com), the work of artist Shepard Fairey. Indeed, as with the 'Obey Giant' campaign, the baby pictures were accompanied by an amateur website, dedicated to investigating the phenomenon of these slightly unsettling images of a baby as 'Big Brother', and mirroring the multiple sites devoted to Fairey and his work. The now defunct investigative amateur website www.whois lupo.com had crude graphics, a weblog and links to 'sister' sites, one of which was the Japanese site for the auto manufacturer Volkswagen.

As cultural commentators, such as *Need to Know* (www. ntk.net), quickly pointed out, the 'street art' was, in fact, part of a teaser campaign for Volkswagen's new model, the Lupo, which had at that time just been released in Japan.[13] The viral marketing involved mimicking the ways in which word of mouth, and now new media networking, creates a 'buzz' within which to launch marketing campaigns. The quick adoption of a new phenomenon of cultural commentary, such as street art, by advertising companies has made it difficult for the latter to maintain its grass-roots, populist image. Even *Need to Know* acknowledged the Lupo teaser campaign as 'Nathanesque'. The episode casts a harsh light on the activities of cultural resistance groups that appeal to youth markets, exchange art- school-trained personnel and enrol followers through the consumption of T-shirts, music and collectibles. The effect can be seen in the widespread adoption of socialist or communist revolutionary imagery by high street stores that market political resistance as a commodity.

New class structures

While Enzensberger was enthused by the new technologies of video, what was really important to him was the connections such technologies offered. Later theorists, especially those who have focused on the political potential of new media, have taken this critique in a new direction. They have acknowledged that what ultimately deterritorialises is capital itself, and it is the independent control of capital by the individual, as a process of self-determination, that leads to true political emancipation. This is the idea that media theorists such as McKenzie Wark have put forward, particularly in relation to his argument that a new class system has developed through new media. Where once was discussed a schism between the labouring class and the state or corporate class, there now exists a new division between massive media conglomerates and an 'underclass' of social activists as hackers. This is a situation created by the new production of immaterial goods in today's new media economy. The modern worker in the Western world is less likely to create objects, and more likely to create knowledge, information, concepts, and the means of communicating them. These might be services offered at a call centre, or an artwork sold in order to enhance the emotional response to an office space. Even if the new Western worker creates *things*, they are not as important as the immaterial value that such things accrue. This means that, for Wark, the two new classes that have emerged are the *hacker class*, which 'arises out of the transformation of information into property, in the form of intellectual property', and the *vectoralist class*, which controls 'the vectors along which information circulates'. Most importantly, Wark also notes that 'the vectoralist class goes out of its way to court the hacker class ideologically'.[14] Hacking as a practice of resistance is always on the verge of co-option into the mainstream.

Wark is profoundly influenced by Michael Hardt and Antonio Negri, economic philosophers who were themselves inspired by Deleuze and Guattari. It is this influence that can be traced to

Wark's understanding of the vectoralist class. Capital, suggest Hardt and Negri, 'operates on the plane of immanence', relying on the equivalence of money to bring all values together in 'quantifiable, commensurable relations'. The rhizomorphic spaces of the Internet, which allow for the free flow of information as a commodity, create an ideal place for capital to flourish because, as they make clear, capital 'tends toward a smooth space defined by uncoded flows, flexibility, continual modulation, and tendential equalization'.[15] Capitalism as a commercial force needs to deterritorialise, to create smooth, unhindered space, in order to reterritorialise and create new money-making formations.

This can be seen in the example of media conglomerates such as Sony Corporation. In 2004, as part of a consortium, Sony bought legendary Hollywood studio Metro Goldwyn Mayer (MGM) for a reported $5 billion. This included the rights to the James Bond franchise, produced by EON Productions, with which it had already established connections for the last Pierce Brosnan film in the series, *Die Another Day* (2002). The purchase of MGM, however, allowed Sony to fully exploit the franchise for the 'reboot' of Bond with Daniel Craig in the role for *Casino Royale* (2006). The film was made by Columbia Pictures and MGM, both now part of Sony Pictures Entertainment, who would go on to distribute the DVD. The music, by David Arnold, would be distributed by Sony's joint-owned subsidiary, Sony BMG. Arnold had previously produced his own interpretation of Bond themes for East West Records, *Shaken and Stirred* (1997), before coming into the Sony fold after he had worked on the Warner-Brothers-distributed music for previous Bond films. This meant that, for Sony, any artistic decisions they made on the film could refer back to the Bond back catalogue with impunity, since there would be no 'rival' company or artist with intellectual property rights. At the same time a massive multimedia campaign was launched, which included silver special-edition models of the Sony Ericsson K800 and K790 Cyber-shot mobile phones, designed to evoke the vintage Aston Martin DB5 that Craig

drives in the film in homage to previous Bond incarnation Sean Connery. The Bond 'product' for Sony was not so much the film but a notion around which to orient an array of products that used the free flow of Sony's internal organisation to create a network of franchise opportunities linked by the film's website.

To draw a picture of vectoralism as entirely mainstream, as Wark tends to do, would be inaccurate, however. The penetration of these umbrella corporations into 'grass-roots' or cult forms, such as comic books, means that they are able to successfully tap new emerging youth markets, especially when they seem to be in opposition to mainstream modes of authorship. Eileen Meehan had very quickly noted this in her analysis of the *Batman* (1989) film and merchandising phenomenon, whereby Warner Communications Inc. were seen to 'cash in' on the success of the graphic novels that reanimated the superhero's career. In fact, as owners of DC comics from 1971, Warner issued the graphic novel *The Dark Knight Returns* as part of their *own* marketing strategy to create a buzz in the run-up to releasing the movie. Warner's investment built the 'basic infrastructure'[16] for future franchising, a model to which can be added information technology and the Internet. In 2002 Sony released *Spider-man,* with a major website that acted as the hub for a fan network, and allowed them to 'pre-sell' the movie by encouraging fan art and fan fiction.

What this means is that resistant objects and practices, such as comic books, culture jamming, viral art, or hacking, which deconstruct capitalism's old hierarchies, can therefore be seen to *assist* in its new formations. The clearest illustration of this is the confused message of libertarianism put forward by Wark, who campaigns intellectually for an exploited underclass, the hackers who produce intellectual property that will be exploited by capitalism's faceless and soulless corporations. Wark asks us to sympathise with individuals who are unable to assert their intellectual property rights in online gaming, who labour within new 'life' games such as *Ultima Online* to create the world that

Electronic Arts (the game's owner) will exploit. Wark and other new media producers in the hacker classes are really a middle class of workers, however; an aspirational new class that has managed to rise above the conditions of manual toil in order to become an empowered part of the new economy. As a middle class, though, they exploit in their own turn the labourers in China, Mexico and other countries, many of them women, who manufacture the equipment (the latest PC, the latest Apple) with which hackers create the new intellectual property. This is the real divide between the classes in the new media economy, a global structure maintained by the virtual structures of the Internet, in which capital deterritorialises and reterritorialises the economy.

This is where Deleuze, Guattari and the politics of connection come in. For Enzensberger, it was important that political empowerment comes not from the complete deconstruction of the apparatuses of ideology, but from an effort to realise the promises that their technologies make. This involves new connections and new types of social interaction, and also involves recognising their power before the state does, before capital does. In this sense it involves seeing the immanent power of the technologies of connection quickly enough to take control in such a manner that they can no longer be co-opted. This is why projects such as *Wikipedia*, for all their factual inaccuracies, have the great potential they do. In making the access to information free, or as free as the access to a computer entails, they take away the investment of money and commerce that normally flows in the free space of the new connections. All that is left is the connection itself. In this way one need only be watchful against reterritorialisation. *Wikipedia* needs to be a contested space in order to prevent it settling into a sedimentary rock of white, Western ideology, in order to prevent a particular way of writing history and recording knowledge from starting to lead or create that knowledge. It needs to be a contested space in order to resist reterritorialisation, in order to fulfil – one day, perhaps – its potential to host the knowledge of a truly worldwide community.

Part Two

Introduction

What is becoming?

One of the sensations any reader might expect from reading Deleuze, especially from reading the work with Guattari, is an overwhelming sense of restlessness, particularly when identity is concerned. Not only is the issue of identity an urgent one for them as philosophers, but their style makes it a recurrent subject around which they orient much of their philosophy. Indeed, this is so because, for Deleuze, identity itself is always in motion: the identity of the individual subject, pressured from all sides by forces that will make him or her, articulate him/her, organise him/her; but also the collective subject, pushed together through environmental, governmental, or social forces, or coming together in a resistance to these. This restlessness creates the subject through coalescence, coagulation and coordination, here moving swiftly, there moving slowly. Identity is always in motion, no matter how rooted it seems or how fixed. Not only that, but all identifications are in motion, since any fixed state of an object is merely a stage of apparent rest before another change. If we pick up a coffee mug and look at it, we can have no doubt that it is a fixed object in time and space. It is, in fact, fixed to the extent of being brittle. It will smash if we drop it, and its 'essential' identity would be at an end. What we are really looking at, however, is a moment (no matter how long) of apparent rest in the life of its molecules and atoms. It was once wet clay, formed and shaped, glazed and fired under pressure. It continues to change, cracks and fissures forming on its surface, until we break it, when it will be

tossed aside as rubbish, returning it to the earth. This 'fixed' object in space is also a fixed object in time (Deleuze called this an 'objectile'[1]) only inasmuch as we isolate it in our minds from the continual change of the universe.

This places Deleuze's philosophy at odds with any other philosophy that focuses on 'being' and what it is 'to be'. Instead, if identity is always in motion, it is always coming-into-being, a never-ending project of *becoming*. It is the simple fact of becoming that is behind the creation of the rhizome, since the rhizome exploits and enjoys continual change and connection, rather than seeking to fix or prevent it. Similarly, as we shall see, it is this continual coming-into-being of all things that is the only thing we can rely on, the only thing that allows us to mark time against the sheer vastness of eternity. Becoming, then, is perhaps the single contribution around which all Deleuze and Guattari's philosophy revolves – the keystone of their philosophy of life itself. For this last reason, becoming is both a guiding principle for the analysis of culture, and an ethical call for a different way of being (or becoming!). The ideas they develop from this central discovery – becoming-woman, becoming-animal, becoming-imperceptible – have become currency in an array of ethical debates including feminism and post-feminism, environmentalism and political science.[2] This has occurred through the philosophy's central usefulness as an interpretive strategy – its ability to help us understand how hierarchies of identity and essence are constructed and resisted. To appreciate becoming as a fact of life, a stage of critical self-awareness, or even an ethical response is to appreciate how identity itself is formed through opposition, alterity and difference.

Deleuze and Guattari note that culture organises itself along principles of 'proportionality', in that, within a symbolic structure where an equivalence of terms is reached, a hierarchy of relations is created as a 'serialization of resemblances with a structuration of differences'.[3] This is a rationalisation of culture made in order

to understand it – as much by sociologists as by ourselves. The problem here is that the principal identity against which this proportionality is measured is *man*, as the screen upon which all identities are projected and found different. The ethical position that Deleuze and Guattari take relies upon the realisation of this principle of difference, even for those who are 'naturally' relegated to a position of subordination. Deleuze and Guattari replace the binary structure with one based on a kind of substantial quality: instead of the binary structure of man–woman, for instance, they suggest that man is the major or molar entity, against which woman is minor. As with much of Deleuze and Guattari's philosophy, however, it is never as simple as that. To truly begin to dismantle and rebuild the hierarchies created by culture's patriarchy, one has not only to confront and pass through the position of the minor, but to appreciate this as a becoming, rather than essential and fixed. Put another way, in order to dismantle a prejudiced system based on sex, gender or race, one has to understand from within the things that make differences *different*. A woman cannot simply be different, she has to pass through this difference, she has to appreciate this difference as being at once symbolic and artificial. Difference has to be felt as a construction rather than as an essence. The same situation obtains for any minority, and, indeed, the collective term that Deleuze and Guattari use is *becoming-minoritarian*. The position becoming-woman takes in this ethical process is significant, since it is the principal binary organisation that culture adopts. Simple opposition to the patriarchal hierarchy is not an option, though; the ethical path is not to be different, but to be imperceptible. This has caused feminist philosophers, such as Rosi Braidotti, to criticise Deleuze and Guattari for suggesting that women give up the only weapon they have, the only agency they possess, in the struggle against discrimination – their femininity.[4]

Fundamental to Deleuze and Guattari's philosophy, however, is the fact that identity is created not by any kind of essential or

material being, but only by reactions by others to what are seen as characteristics. Becomings are made up of a variety of these that act as markers, or compositional elements. Any essential identity, no matter how different from *man*, would simply be another molar one. True becomings are molecular, since they are made up of elements and characteristics that may at any time change and reform. For this reason the notion of contagion and cross-contamination becomes essential to understanding identity as contingent, to create a sense of self-awareness and empowerment. When a man turns into a wolf in horror fiction he does not become just another wolf, he is infected with the characteristics of the wolf (as we have seen, the wolf is a constant presence in *A Thousand Plateaus*). Similarly, the soldier who dresses as a woman in order to escape, or even in order to entertain other soldiers, does not imitate a woman, nor become a woman, but understands suddenly the struggle that women face when reduced to their essential characteristics.

It helps, here, if we use an example that illustrates not just becoming-woman, but also the wider aspect of identity spread through contagion – this time in the wartime concert party. This has been a staple of British culture for many years, perhaps having its most famous manifestation in the BBC TV show *It Ain't Half Hot Mum* (1974–81). The show followed the exploits of a British army concert party stationed in Burma during World War II, with episodes that often revolved around the staging of the shows to troops, and in which the soldiers play both male and female characters. While some of the soldiers, especially Bombardier Beaumont (Melvyn Hayes), are played along the lines of lower middle-class high camp, it is often the burlier characters, Mackintosh (Stuart McGugan) and Evans (Mike Kinsey), representing working-class backgrounds from provincial Britain, who get the best laughs. It is when these men complain of the impracticality of wearing women's underwear, rather than the ostensibly homosexual Beaumont, that we see the soldier as

becoming-woman. This is because their becoming-woman occurs not through sexuality but, instead, toward affinity: it allows them to engage in the kind of social bonding and subsequent loyalty that is normally off-limits to men but expected in women, and seen as a sign of their social difference and inferiority. Becoming is an operation of the social as well as personal identity, in that the collective identity of groups also works through contagion. It helps here if we continue to think of the group of soldiers who are brought together by circumstance (often hardship, catastrophe) and who form a collective bond. As Deleuze and Guattari describe: 'Bands, human or animal, proliferate by contagion, epidemics, battlefields, and catastrophes.'[5] Their multiplicity is an essential part of the war machine, the unit being made up not only of gunners and bombardiers, but also of pianists, singers, dancers. We understand them as having a filial bond even though they are brought together by events and kept together by camaraderie. Just as when King Henry, in Shakespeare's *Henry V*, describes his 'band of brothers', we recognise that it is a shared identity of affinity, rather than blood connection, that is experienced by this band of brothers in the jungle. They share a becoming-animal in living in trenches and especially 'foxholes', but, most importantly, their affinity is created by shared humour in the face of adversity – humour that is the contagion that connects them all. This is what we mean when we say that 'laughter is infectious'.

So how, then, does one locate oneself within this dizzying multiplicity of becoming, this restless change of identity? Deleuze and Guattari's answer is that we represent intersections of time and place, coordinates within social structures. They use the analogy of longitude and latitude. The geographical metaphor is succinct: culture is dizzying, it is easy to get lost, and what we need is a kind of GPS (Global Positioning System) device that will pinpoint us and our identity. The metaphor doesn't rest there, however, even though Deleuze and Guattari were writing long before hand-held devices and global satellite surveillance.

Latitude, for them, is a way of describing the accidental genesis of our identity – it is an accident of birth that we might be white or south Asian, that we might be male or female. Intersecting this is the specific materiality of our own bodies, longitude, and together they create only an intersection of degrees, what Deleuze and Guattari call a '*haecceity*'.[6] The metaphor is apposite, though: what you get at the intersection is a point, a location, which tells us very little until it moves. It might be an accidental genesis that gave us our point on a cultural, societal map, but it's up to us how we use our potential becoming, up to us how we move. After all, as Deleuze and Guattari say: 'We know nothing about a body until we know what it can do.'[7]

Chapter 3

Minor cinemas

David Martin-Jones

Deleuze and Guattari's concept of the minor is an extremely useful way of understanding power relations in today's world, in particular in contexts where issues such as post-colonialism and globalisation influence how people conceive of their identities. This chapter first describes the origins of the term. It then briefly discusses several of the different ways in which it has been applied to cinema, creating the concept of a minor cinema. Finally, the American independent film *Mysterious Skin* (2004), by cult director Gregg Araki, is analysed as a work of minor cinema. *Mysterious Skin* is a work of minor cinema created outside the mainstream and designed to question the 'norms' of identity usually propagated by Hollywood. It suggests the possibility of various different types of minoritarian American identity by examining sexual desire in the contemporary United States.

What does 'minor' mean?

In 1975 Deleuze and Guattari introduced the idea of the minor in a book on Franz Kafka, *Kafka: Toward a minor literature*. In 1980 they developed the idea in *A Thousand Plateaus*. In *Kafka*, Deleuze and Guattari argued that, as a Czech Jew living in Prague but writing in German, Kafka's work could be considered an example of minor literature. For Deleuze and Guattari, Kafka took the major, or dominant language that spoke for the various countries in the Austro-Hungarian Empire (i.e. German), and made this official or 'paper language'[1] – which was not spoken by the majority of Czechs

– speak in a minor way. In political terms, Kafka's grotesque, surreal and bizarre world could be interpreted as a product of the colonial situation in which he wrote, as the Czechs struggled for independence from the Austro-Hungarian Empire.[2] In *A Thousand Plateaus*, Deleuze and Guattari note that to make a major language speak in a minor way is to make it stutter, stammer or even wail.[3] Thus a minor language is not established in opposition to a major language. After all, Kafka did not use the Czech language to oppose German. Instead a minor language, takes a major language, and, by deterritorialising it, forces it to become something else.

At the extreme end of this process of becoming, Deleuze and Guattari describe the deterritorialisation of a major language as its transformation into something more like music.[4] The terms 'major' and 'minor', they explain, can be understood as musical terms. A minor language plays the same tune as the major language, it just plays it in a minor key.[5] For instance, a Caribbean Creole might jumble together a colonial European language and an African language derived from a slave community's country of origin. It thereby makes a major European voice sound in a minor key. Alternatively, the rhythmical rhyming of rap or hip hop can be considered minor when used to express a different type of identity – such as that of African-Americans, or France's different ethnic and racial minorities – from that usually spoken by the dominant language of these countries.

It must be understood, however, that 'minor' does not always equal 'minority'. While Kafka was a Czech Jew subject to a colonial situation, and in that sense in the minority, he was also a wealthy member of the bourgeoisie who spoke German as his first language. To work in a minor way, then, is not necessarily to be a 'minority' in the way this term is usually deployed, with all its negative connotations of economic, gender, racial and ethnic status. To be minor is to take a major voice, and speak it in a way that expresses your preferred identity. This political aspect of the minor is crucial, for minor practices (art, literature, language) have

the potential to destabilise the normal conventions of the major voice of a society. To act in a minor way, then, is not to oppose a dominant political system, but to inhabit the system and change it from within. Thus, although Deleuze and Guattari's work on Kafka was originally focused on the way a minor language could be created in literature, their idea of the minor can be applied to any number of contexts, including cinema.

Modern political cinema

Deleuze and Guattari did not define clearly how their idea of the minor could be applied to cinema. Rather, it was in the second volume of Deleuze's solo work on cinema, *Cinema 2* (1985), that he began to illustrate how the minor could exist in cinema. In *Cinema 2*, Deleuze returned to the idea of the minor under a different name. Discussing what he now called 'modern political cinema',[6] Deleuze draws parallels between certain filmmakers and his earlier ideas concerning Kafka.[7] Initially he mentions several French directors, such as Alain Resnais, Jean Rouch and Jean-Marie Straub, but before long his work focuses on more globally marginalised filmmakers, such as Yilmaz Güney, Youssef Chahine, Glauber Rocha, Pierre Perrault and Ousmane Sembene. The works of these directors – from Turkey, Egypt, Brazil, Quebec (Canada) and Senegal respectively – more clearly illustrate what is at stake in the notion of modern political cinema. The films of these directors contrast the output of the mainstream film industries in their countries of origin, as many of them have renounced commercial gain and attempted to use cinema to create new identities under difficult political circumstances.

In all these instances the countries in question were facing political turmoil. For instance: Sembene's Senegal was a newly post-colonial country; Rocha's Brazil was under military rule, as was Güney's Turkey (whose population was also divided over the issue of Kurdish identity in Turkey); Perrault's Quebec struggled for independence from Canada; and so on. At one point Deleuze

points out that it was much easier for such filmmakers to see that the people were missing 'in the third world, where oppressed and exploited nations remained in a state of perpetual minorities, in a collective identity crisis'.[8] Modern political cinema, then, was mostly likely to be found in the Third World, as it was concerned with the creation of new identities, of a people who are 'missing' or yet 'to come'.[9]

Effectively, modern political cinema is minor cinema. In *Cinema 2*, Deleuze only slightly adapts the three characteristics of minor literature found in chapter 3 of *Kafka* ('What is Minor Literature?') to create the idea of a modern political cinema. Firstly, he notes how modern political cinema attempts to create a new sense of identity for the future, or a people yet to come. This he does by contrasting it with the unproblematic conception of 'the people' found in classical cinemas, such as the films of Frank Capra in the United States (think of Christmas-time classics such as *It's a Wonderful Life* (1946)), and the most distinctive of the Soviet Montage directors, Sergei Eisenstein, whose 'Odessa Steps' sequence in *Battleship Potemkin* (1925) is one of the most famous in cinema history. In these classical cinemas it is taken as read that the people of the United States, or the Soviet people, already exist. For the filmmaker it is simply a question of shaping the identity of that people. In Capra's cinema this is often done by evoking the righteousness of democratic, small-town family values in the United States or, in Eisenstein, the revolutionary potential of the proletariat in the Soviet Union. In the works of the directors of modern political cinema, however, the people do not exist in a readily accessible mass. Rather, these films show the people struggling to emerge under political conditions that would deny their different identities.

Secondly, Deleuze discusses the eradication of the division between public and private spaces in modern political cinema, noting how this makes all personal actions inherently political. Protagonists in these cinemas do not have the luxury of a secure, distinctive space of the family. Rather, characters often inhabit the

'cramped spaces' of society's margins, spaces that are too easily invaded by the official forces of the public realm.[10] For this reason it is not possible for minor characters to transfer a certain set of values learned in the home to their public lives, as private acts quickly become public acts due to the monitoring of the lives of minor characters by the controlling forces of society.

For a concrete filmic example of this type of existence, consider the French film *La Haine* (1995). Set in the Parisian *banlieue* (the run-down housing projects on the outskirts of Paris), *La Haine* follows the adventures of three unemployed teenagers, Vinz (Vincent Cassell), Hubert (Hubert Koundé), and Saïd (Saïd Taghmaoui). With France's manufacturing industry in decline, the male population of the *banlieue* finds itself redundant, and violent clashes with the police soon follow. The three post-colonial youths find their cramped home lives constantly invaded and monitored by the police and the media. Practically every action they take therefore has a political edge, as is seen most clearly in the desire of Vinz to take revenge for the murder of their friend at the hands of the riot police. Under such circumstances, whenever and however the individual acts, he or she makes a political statement that resonates within the public sphere. Although this is a rather negative situation to exist in, it also contains the potential for minor actions to impact directly upon society.

Finally, Deleuze argues that modern political cinema is marked by a refusal either to reproduce negative stereotypes, or to oppose such types with 'positive' stereotypes. For Deleuze, either practice creates a colonising (or in some cases a neo-colonising) image of the people. Rather than enabling the creation of a new people, this practice fixes one image of the people in place, thereby halting their transformation into something else in the future. Instead, modern political cinema multiplies characters, to illustrate how the identity of the people to come will never stop transforming. As part and parcel of this process, directors of modern political cinema often base stories around characters

involved in creating stories of their own identity. In this way the films themselves refuse to establish one single, authorial point of view. After all, to posit one authoritarian view on a political situation is not a minor action, it is an opposition. Instead, minor films often enter into a dialogue over which fiction (that of the film, or the stories told within the film) can best establish a new identity for a people yet to come. For this reason minor cinema can at times appear self-consciously stylised. Directors of minor film do not create a solid image of a new identity so much as question the manner in which identities are usually constructed in mainstream cinema. In this way, the major voice of cinema begins to stutter, stammer or wail, without too quickly reterritorialising 'the people' into a new stereotype.

Nevertheless Deleuze's theory of modern political cinema is in many ways quite vague. He never really gives concrete examples of exactly *how* it takes the dominant language of classical cinema and makes it speak in a minor voice. His ideas are practically impossible to grasp unless you have seen the films he briefly references, and even then his lack of sustained concrete analysis erects further barriers to our understanding. Fortunately, several scholars have taken his ideas and applied them with rigour to various cinemas. Let us now turn to a few of them to enhance our understanding of modern political cinema, or, minor cinema.

Minor cinema

Probably the first person to coin the phrase 'minor cinema' in English was D. N. Rodowick, in *Gilles Deleuze's Time Machine* (1997).[11] Rodowick discussed how post-colonial west African nations, such as Senegal in the 1960s, used cinema to rethink their identity after an extensive period of occupation by the French. Previously, cinema had been used by the French to represent the native west Africans. French cinema was a major voice that very

often represented west African identity in a negative manner, as a primitive culture. For this reason west African filmmakers had to struggle against not only the dominant language of the coloniser, French, itself, but also French cinema when it positioned west African people as colonial subjects.

Rodowick analyses Ousmane Sembene's *Borom Sarret* (1963) as a work of minor cinema.[12] Often considered the first indigenous African film, *Borom Sarret* is the story of a taxi driver (with a horse-drawn cart) from a poor district of Dakar, the capital of Senegal. Rodowick comments in particular on Sembene's utilisation of African oral storytelling traditions to make a minor use of the norms of Western cinematic representation. Rodowick demonstrates how the sound recording of the film gives it the feel of a story told verbally, as though in the African oral tradition. The sound is deliberately non-naturalistic (i.e. it does not always match the image), and many of the characters' voices are spoken by Sembene himself. This has a peculiar effect on the spectator, who is used to seeing images constructed to appear 'naturalistic', or as though they objectively reflect reality. In the case of French cinema's previous representation of west Africans, this naturalism was used as a disguise behind which to propagate the negative image of west African culture as essentially primitive. By contrast, Sembene creates a film in which images and soundtrack are dislocated, and the normal experience of watching a story unfold in cinematic images suddenly appears to stutter, due to the minor actions of the filmmaker. Instead, the film appears rather like a story addressed to the various types of native Senegalese people that it depicts, asking them to question how they can create a new collective, how they can become a people of the future. Since Rodowick's intercession a number of works have emerged that describe how minor cinemas are created in different contexts, from small national cinemas, to exiled and diasporic cinemas, to women's cinema.[13] As one illustrative example, let us now consider the US independent film *Mysterious Skin*.

American independent cinema as minor cinema:
Gregg Araki

The films of iconoclastic director Gregg Araki belong to a long tradition of queer American independent cinema that includes such notable directors as Kenneth Anger, John Waters and Andy Warhol. As queer cinema is usually created outside the mainstream it very often has the potential to be minor, although it is often more oppositional than minor. On the other hand, in *The Celluloid Closet* (1987), Vito Russo has exhaustively charted the long history of mainstream Hollywood films that were queered in a minor way by writers, directors or actors willing to slip a queer theme or subtext into a mainstream film. Here we see a far more minor queering of the accepted norms of the mainstream. Araki's films are part of a movement that developed in the 1990s called New Queer Cinema, and as such they often straddle these two worlds.[14] Many of his films are independent films with queer subjects, and as such are perfect for creating minor cinema. In addition, though, they very often attempt a degree of crossover into the mainstream by utilising established genres or styles, even while queering them, and making them speak in a minor way. Thus it is primarily through his focus on queer sexualities (be they homosexual or otherwise 'deviant' from the established heterosexual norm) that Araki is able to question various dominant norms of US identity.

Mysterious Skin (2004)

Mysterious Skin is the story of two young teenagers, Neil McCormick (Joseph Gordon-Levitt) and Brian Lackey (Brady Corbet), living in the small town of Hutchinson, Kansas. Both boys were sexually abused by the local Little League baseball coach (Bill Sage) when they were eight years old. Brian is now a sad teen, troubled by traumatic memories for which he has no rational explanation. Instead, he concocts theories of alien abduction to explain his blackouts and lost memories. Neil, on the other hand, had his heart broken at eight by the coach (who disappeared

suddenly), and has since become a rent boy with a nihilistic, even self-destructive approach to life. When Brian seeks out Neil looking for answers Neil takes him to the coach's old house and reveals the truth to him.

Mysterious Skin clearly conforms to the three characteristics of a work of minor cinema. Firstly, its teenaged protagonists create a bizarre assemblage that deterritorialises standard norms of behaviour, suggesting a new model for a people yet to come. Neil's homosexuality ensures that Wendy (Michelle Trachtenberg) and he, although friends since childhood, do not become lovers. The protagonist's romance with the 'girl next door' seen in so much US suburban drama is thus unavailable to them. Brian, for his part, is so traumatised by his partial memories of abuse that he has become, as Neil's friend Eric (Jeffrey Licon) describes him, 'weirdly asexual'. When fellow alien nutcase Avalyn Friesen (Mary Lynn Rajskub) attempts to seduce him, Brian is unable to reciprocate.

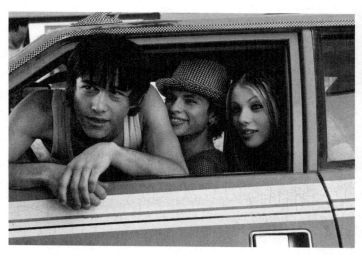

1. *Mysterious Skin* (2004).

Thus Araki's queer politics deterritorialises the heterosexual coupling typical of the US teen film.

If there is a people yet to come in this film it is clear that it will have to emerge from the wounded teens who have spent their lives having their expectations of what life 'should' be like (which they have learned from the movies) dashed by reality. Thus Wendy often performs the role of caring mother to Neil, and Neil and Eric take turns caring for the traumatised Brian. Unlike the teens in typical teen movies there is no romantic resolution for any of these characters. Instead, they all learn to face the uncertain future and to try and support each other. The casting of Joseph Gordon-Levitt as the teen hustler Neil is key in this respect, as he is well known for playing wholesome hetero teens who do get the girl in both the TV series *Third Rock from the Sun* (1996–2001) and the teen flick *10 Things I Hate About You* (1999). Audience expectations are rocked by his performance, as Araki plays out our normal expectations in a minor key, forcing us to confront the possibility that the normative representation that we are used to may require deterritorialising if a new identity is to be created. Indeed, it was undoubtedly this uncharacteristic performance that enabled Gordon-Levitt to cross over into the US independent sector and then secure the lead in the teen noir *Brick* (2006).

The second criterion for a work of minor cinema is also met, as the film eradicates the boundary between political and private spaces. As a hustler, Neil inhabits marginal spaces, such as motel rooms, cars, bus terminal toilets and the children's playground where he waits for clients. Through Neil's illicit sexual activities we witness a life lived aimlessly in public places. In fact, it transpires that Neil's relationship with the private sphere was adversely affected when he was a child. His first ejaculation occurred when he was just a small boy, watching his mother give her latest boyfriend a blow job on the ladder of his garden swing set. Here the public sphere invaded his childhood sanctuary, and it is no accident that, as a teenage hustler Neil hangs around a

public children's playground (complete with swings and slide), waiting for clients. Public and private have become one and the same for Neil, who associates sex with symbols of childhood that for him have lost their usual connotations of innocent play. In fact, as his mother is frequently drunk or absent, Neil effectively functions without the privacy of a secure home. For this reason he falls for the coach, who stocks his house with food and games appealing to young children, and generally performs the role of Neil's absent father by giving him lifts home after baseball practice. The invasion of sex into Neil's fractured home life, and the false security offered by the coach's house (where his surrogate father sexually abuses him), have destroyed Neil's access to a private life, and as a teenager he lives his life entirely in public spaces. The sanctuary of white suburbia usually upheld by Hollywood (again, think no further than *It's a Wonderful Life*) is here shown to be a lie.

Fulfilling the third criterion of a work of minor cinema, Araki's self-conscious cinematic style is used to insert the film into a dialogue between filmmaker, fictional story and audience, in a similar manner to that which Rodowick describes in Sembene's *Borom Sarret*. In doing so he avoids the creation of new, 'positive' queer stereotypes, preferring instead to proliferate the possibilities of diverse teenage identities. Part and parcel of this approach is a self-conscious exploration of style.

As numerous critics have noted, Araki's films stand out from the mainstream due to his incorporation of aspects of the avant-garde.[15] As opposed to the transparency of form adopted by Hollywood (which attempts to suck the viewer into its fictional world and avoids drawing attention to its constructed nature at all costs), the avant-garde foregrounds the fictional status of the film, asking the viewer to think about how the world is 'normally' represented to them by film. In *Mysterious Skin* the effect of distancing the spectator from the story is achieved by stylistically inhabiting the Hollywood norm and using it to tell a story that

questions the usual sexual identity of the Hollywood teen film, while self-consciously referencing previous famous Hollywood productions about small-town life. In this way *Mysterious Skin* appears as though a story told in cinematic quotation marks. The viewer is confronted with numerous images that seem familiar, but have been 'queered' to such an extent that they can only question our perception of what is normal.

Early on in the film Wendy and Neil stand in a deserted drive-in, and fantasise about how their lives might look if they were in a film. As they listen to the 'voice of God' through the speaker it begins to snow. Neil and Wendy look up to the heavens. A reverse shot then follows, taken from a crane looking directly down on them, showing them looking up as the snow falls. This is in fact a direct cinematic reference to the opening of Frank Capra's tale of small-town American life, *It's a Wonderful Life*. In the earlier film a shot/reverse shot sequence is used to create a dialogue between a family praying for their father George Bailey (James Stewart) in the small American town of Bedford Falls and an answering discussion between angels in heaven.[16] We literally follow the prayers as they fly to heaven, and witness a conversation between angels as they decide how to respond. In *Mysterious Skin*, however, a shot of the heavens seen from the point of view of the characters on earth is absent. Even though the characters claim to hear the voice of God from the silent drive-in movie speakers, their view of heaven is not shown to the spectator, and there is no conversation between protective angels. In fact, as the impassive camera's aerial stare suggests, heaven has abandoned these characters, just as both Neil and Brian's fathers have abandoned them to the care of their working mothers. The effect of this seeming renunciation of all patriarchal values, whether religious or familial, is compounded when teenage Neil gets drunk one night and visits the coach's old house. Confronting this closed door to the past, he mutters bitterly that the coach, his surrogate father figure, had once referred to him as his 'angel'. The

film uses the notion of abandoned souls to suggest that, for Wendy and Neil, the heavenly redemption available to George Bailey in the small American town of Bedford Falls in *It's a Wonderful Life* is not available. Their identity is no longer that of the wholesome, 'saved' America of the immediate post-war years.

This replaying of Hollywood myths in a minor way occurs several times in the film. When Neil and Wendy are in New York, Wendy warns Neil to be careful by referencing Dorothy in *The Wizard of Oz* (1939), saying: 'We're not in Kansas anymore.' This time, however, unlike Dorothy, these characters have no utopian family home to return to by clicking their heels. More obviously, during the film's Halloween sequence the safe suburban excitement of Halloween seen in Hollywood classics of the past such as *Meet Me in St. Louis* (1944) and *E.T.: The Extra Terrestrial* (1982) is made to stutter when Neil physically and sexually abuses a disabled boy in the manner he has learned from the coach, and when Brian is once again sexually abused by the coach.

Finally, Araki's decision to shoot the scenes of child abuse in a manner that did not traumatise the child actors creates a further minor effect. For the abuse sequences Araki filmed the children and the coach separately, as though they were reacting to each other, although in reality the other party was absent. He then edited the shots together, creating the illusion that both parties were present at the same time.[17] This technique is called the Kuleshov effect after the Soviet filmmaker Lev Kuleshov who, in the late 1910s, discovered that audiences would infer that shots filmed separately belonged to the same space and time. In Hollywood cinema the Kuleshov effect is typically used to bolster the illusion that the fictional world of the film is 'real', and not a created fiction. It furthers the aim of Hollywood cinema, to suck the viewer into an unquestioning relationship with the narrative world. For instance, the Kuleshov effect is often used to make spectacular stunts appear real in action-packed blockbusters. A shot of an explosion may be followed by a shot of an actor reacting

to it, even though he or she is nowhere near the actual event. In this instance, however, a technique usually deployed to make the audience feel unquestioningly secure in their relationship with the film (even as it constructs ideological norms, such as that of heterosexual primacy) actually makes the viewer feel extremely uneasy. The scenes look so real that they are twice as frightening, especially when we are placed in the position of the children, looking up from their point of view, at close-ups of huge adult faces that fill the screen. The spectator's desire to believe that fictional images are real is purposefully played upon, the illusion of reality that normally enhances naturalism here making us squirm, as it positions us in the role of abused child. Replaying this major technique in a minor way renders literal the way this procedure usually makes us, as spectators, subject to a potentially abusive ideology.

In the final scene, *Mysterious Skin* provides some respite for its characters, as Neil and Brian break into the coach's old house, and Neil helps Brian come to terms with what happened to them when they were eight. In one respect, then, the film finally recoups the suburban home as a place of sanctuary and healing. This private space is only a temporary space for these characters, however, who will ultimately have to leave it again to get on with their lives. Once again, the film plays the accepted image of the suburban home in a minor key, and it does so to suggest that a people of the future can be created only by excavating the dark and hidden pasts obscured by this homely image so often peddled by Hollywood, just as Neil and Brian are 'healed' by their final encounter with it. In this way the film refuses to propagate either existing stereotypes of homosexuality or heterosexuality, and instead develops the narratives of several damaged teens, whose identities are constantly in the process of renegotiation in the narrative – a process that is mirrored in the film's renegotiation of Hollywood myths.

Chapter 4

Becoming art

Damian Sutton

What does it mean, for Deleuze and Guattari, to be an artist? Deleuze and Guattari consider artists almost within the same breath as philosophers, in the sense that artists have glimpsed something of the immanence that holds the universe together in its tremendous forces and flows: 'They have seen something in life that is too much for anyone, too much for themselves.'[1] This idea of the artist as a kind of philosopher is attractive, but we might struggle if we attach it to any artist, or any artwork. Art can be a kind of philosophy, but this is not the same thing as saying that art is philosophy. The idea of the artist as philosopher sounds useful when attached to Pablo Picasso, and the notion can even seem to elevate your practice or ours as artists. What happens, however, when we attach the term 'art' in this context to Thomas Kinkade or Jack Vettriano? Is the artist a philosopher then? Perhaps this is why, for Deleuze and Guattari, art is one step removed from philosophy. Art is, as Gregg Lambert has suggested, a kind of 'non-philosophy', an approach that cannot be philosophy, but which ultimately has the capacity to enliven philosophy. For instance, the philosopher has a responsibility to knowledge that the artist does not, that of the creation of concepts. Lambert suggests, however, that 'it is only in its encounters with non-philosophy that, following Deleuze's assertion, the task of concept creation can be proposed anew'.[2] Art exists to reveal and give shape to the problems and concepts with which philosophy grapples. When philosophy grows tired, or reaches an impasse, it

is the artistic event that throws up new challenges as it presents those concepts and problems afresh.

What, then, does art do, if it cannot be philosophy? For Deleuze and Guattari, this is very clear. Only philosophy can suppose the plane of immanence, the non-organic life that runs through the universe, giving it shape and form. Art can suppose the shapes themselves, however, and can give us a glimpse of that immanence. It does this by creating pure sensations that exist beyond particular readings; Deleuze and Guattari call these *percepts*, and call the pure responses that exist beyond particular meaning *affects*. In so doing, art is able to do more than simply illustrate the problems and concepts with which philosophy works: it is able to ask some of the same questions of culture that philosophy does, even if it gets different kinds of answers.

Why is there no becoming-man?[3]

In a black and white photograph from 1988, an ageing, elegantly presented man stares out at the camera from a deep black background. He is out of focus, and the camera instead has brought into sharp clarity the skull that decorates the walking cane that he holds in his hand. This is one of the last photographs that the artist Robert Mapplethorpe took of himself before his death, and it seems to represent the intersection of a body of work with the body of the artist himself, as the art world sought to create the artist who was Mapplethorpe.

This American artist/photographer passed away from an AIDS/HIV-related infection in March 1989. At the time, a major retrospective of Mapplethorpe's work, *The Perfect Moment*, was on a tour of the United States that was to include Philadelphia, Boston, Hartford and Washington DC. The work included still-life photographs of flowers and statues and images of the bodybuilder Lisa Lyons, as well as many of his self-portraits. The exhibition also included the 'X' portfolio, a series of images of gay sadomasochism, the 'Y' portfolio of flowers, and the 'Z' portfolio

of black male nudes. Finally, the exhibit included images of the children of Mapplethorpe's friends. His photography represented experimental and oppositional sexuality, in direct confrontation with the academy, and in the tradition of nineteenth-century painters Gustave Courbet and Edouard Manet, who had confronted the sexualised gaze of art in their own time. At the same time, the aesthetic strictness of Mapplethorpe's approach – tightly composed, classical, highly finished photographic prints – demonstrated what Kobena Mercer has called a 'fundamental conservatism', implicating him in the very culture of sexual objectification he seemed to reject.[4] The self-portrait of Mapplethorpe therefore seems also to embody this kind of dichotomy: the more he seems to oppose the mainstream, heterosexual and conservative ideas of art, the more his opposition helps substantiate the mainstream. This is apparent in the circumstances surrounding *The Perfect Moment*, and the aftermath of Mapplethorpe's death – circumstances that reterritorialise the queer look of his photography.

Even at the moment of his death, Mapplethorpe became a standard-bearer, willing or not, for a number of political issues – including the right to free speech – that were seen to be under attack as the American right gathered its forces as part of what became known as 'the culture wars'. These forces had as their figurehead the Republican senator for North Carolina, Jesse Helms. Helms had previously lobbied against the federal funding of health programmes to promote safe sex and AIDS education, and, for writers such as Richard Meyer and Steven C. Dubin, it was Helms in particular who would come to stand for the political right's opposition to Mapplethorpe and his work.[5] In so doing, Helms would in fact be the principal agent in creating Mapplethorpe-the-artist, whose work has a particular set of meanings. *The Perfect Moment* was on show at the Museum of Contemporary Art, Chicago, without much incident, when the news came of Mapplethorpe's death. The artist's battle with AIDS-related

infection, and the subject matter of some of his most confrontational photography, made the final connection for Helms between homosexuality and disease. The show was due to go to the Corcoran Gallery of Art in Washington DC in July, and would be within a city block of the White House and down the Mall from the Senate. For Helms, this meant that his intervention would seem providential: he would have an opportunity to safeguard the nation's morals and be given license by circumstance to do it in the Capitol itself. The director of the Corcoran, Christina Orr-Cahall, cancelled the show, citing the political climate, and it at once polarised the two camps, even uniting groups of artists who had previously had different opinions over the work. Critics of Mapplethorpe's work, such as Mercer, had cited the objectification of black men in his work, which at best reduced them to sexual stereotypes and at worst recalled the days of slavery and the traffic in the black male body. Now, however, they were united in their belief that the work should be shown, and demonstrated this in a mass rally outside the Corcoran, projecting images from the show onto the building and making the covers of several major magazines. Another gallery, the Washington Project for the Arts, picked up the show, and Orr-Cahall later resigned.

In the meantime, Helms had lobbied for an amendment that would restrict the use of federal funds, specifically the National Endowment for Arts, for art that included obscene or indecent materials. Crucially, this included depictions of sadomasochism, homoeroticism and the exploitation of children.[6] Helms would once again equate homosexuality with obscenity and illegality in the public mind, and in particular equate homosexuality with the abuse of children – and the diverse work of Mapplethorpe would illustrate this. Helms used four photographs from the exhibit, including two unclothed photographs of children, when lobbying. The other two images were of men with their genitals exposed, perhaps the most famous of these images being *Man in Polyester Suit* (1980), in which a black man in a suit is photographed from

the chest down, his penis exposed. The amendment, which was eventually passed by Congress, would therefore also reconnect black sexuality with indecency and fear, in a manner that recalled once again the era of slavery.

When the exhibition removed to Cincinnati, Ohio, similar events unfolded on a more local scale. Here, the Contemporary Arts Center put the show on, only for director Dennis Barrie to find himself in court for pandering obscenity after a sustained campaign by a coalition of conservative pressure groups. Here, the defence argued for Barrie that the definition of obscenity had three criteria based on a previous landmark case (*Miller vs State of California*, 1973): the average person must observe a prurient interest in sex in the work taken as a whole; the work must depict sexual conduct defined by the host state as patently offensive; and the work must lack serious literary, artistic, historic or scientific value.[7] Barrie's defence counsel was able to argue, successfully, that the case for the work lacking serious value could not be proven, and all three necessary criteria were not met. This was helped by affidavits from the parents of the children involved, as well as testimonies from art professionals that acted as 'crash courses in aesthetics' for the jurors. As Dubin further notes, this was intended to 'deflect attention away from the difficult subject matter of the photographs, onto formalist considerations such as composition'.[8] Even the term 'taken as a whole' was a challenge for the system, however, with different meanings understood by all parties. The judge and jury agreed that this meant individual images, rather than the whole exhibit, as the prosecution's case suggested. Nonetheless, even within the successful defence of Barrie there was the development of a particular, unified identity to Mapplethorpe's work. For, while only three of the photographs were cited, it was clearly the whole show that was on trial, and the whole show stood for Mapplethorpe (as retrospectives are intended). At stake, then, was the reputation and insistent meaning behind Mapplethorpe's life and career, bound up with his development as a person.

Mapplethorpe was reduced to particular characteristics that stand for his work, becoming a concept for critics of all types. In this way, the polishing of Mapplethorpe's career in the retrospective, and the controversy that surrounded it, acted in much the same way as Mapplethorpe's images of black men that Mercer had criticised. Mercer focused on the ways in which the photographs reduce the black male to the level of the flowers or statues, as things. The images of black male nudes simply replaced one system of sexualised representation in art with another: 'Substituting the socially inferior subject, black/man for the conventional ideal of the (white)/woman, Mapplethorpe draws on the codes of the genre to frame his way of seeing black male bodies as "beautiful things", erotic and aesthetic objects.'[9] The trials of Robert Mapplethorpe, first in the Senate and later in Cincinnati, served to highlight the growing problem of AIDS/HIV and stimulated awareness among liberals and conservatives alike. Helms and others had unwittingly provided opportunities for campaigners against homophobia, and the record-breaking attendance at the galleries that showed the work helped strengthen AIDS awareness campaigns. These were a by-product, however, of the creation, in social, cultural and legal terms, of the artist and his body of work, to the extent that his very image comes to stand for it. Moreover, at the same time, so Mercer's argument runs, this body of work had re-established the principles of difference in representation in slightly new lines only: the black man's body 'invested with what the white male subject wants to see'.[10]

A woman has to become-woman...

At first glance the question 'Why is there no becoming-man?' seems straightforward enough to answer: becoming deterritorialises man from his position as the molar entity around which all others are structured (capitalism, patriarchy). '[M]an is majoritarian par excellence ... the determination of a state of standard,' Deleuze and

Guattari propose.[11] Artists work to raise this as a twofold issue of experience. On the one hand, there are different experiences of the world from that of man, and particularly white men. On the other hand, those different experiences are also experiences of difference itself. As we find with the work of Mapplethorpe, artworks that highlight difference, especially within the aesthetic or formal constraints of art practice, often recreate the systems of difference. This illustrates the power of the patriarchal system that has man as its standard – it even constructs the very terms of opposition, the terms of difference itself.

We might see this in the way that, in art history, a canon of male artists has been created, to the exclusion of women artists as well as artists of colour. For this reason, artists have developed their work to oppose this canon. Some, such as the artists' collective the Guerilla Girls, directly challenge the established histories through publishing and protest. Others, such as Judy Chicago, have sought to create artworks that highlight a forgotten canon of important women writers and artists. 'The Dinner Party' (1974–9), Chicago's most famous work, is an installation of a huge triangular banqueting table, set for thirty-nine inspirational women from history, in which each is represented by a ceramic plate decorated with vulvar and flower forms. The setting also includes the names of 999 other important women, and the whole is finished with elaborate gold and white decorations. Thus Chicago sets her canon of women in opposition to the male canon, within a social context that invokes domestic labour and social propriety. Dinner parties are traditionally the responsibility of the woman as homemaker, and involve couples in an iteration of the heterosexual, patriarchal order. The extra dimension is given by the place settings themselves, however, which evoke the female sexual organs and serve to remind us that it is only this basic difference that separates one canon from the other.

Nevertheless, the highlighting of 'man' as the majoritarian form that leads to social inequality represents only one dimension to the

concept that Deleuze and Guattari wanted to create. They wanted to go further, and attack the very principle of difference itself. This is what they mean by effectively asking the question, 'Why is there no becoming-man?' It allows them to discuss the problem of setting up oppositions. To create an alternative canon is problematic, since it manages to keep in place the very situation of difference it appears to deconstruct. New canons of women artists are in danger of a kind of ghettoisation:

It is important not to confuse 'minoritarian,' as a becoming or process, with a 'minority,' as an aggregate or state. Jews, Gypsies, etc., may constitute minorities under certain conditions, but that in itself does not make them becomings. One reterritorializes, or allows oneself to be reterritorialized, on a minority as a state; but in a becoming, one is deterritorialized.[12]

So, for Deleuze and Guattari, it is not a physical or essential identity that initiates or gives dynamic power to becoming, but instead it is provoked by the social operation of difference. In a sense, this means that a woman even has to distance herself from her difference, to see it anew, and regain some of the agency that this offers her. She does not automatically have it, but it is created for her by her difference from the majority/standard (man) and it rises up from her minority (woman as domestic, as weak, as disenfranchised). This is what gives contemporary performance art such extraordinary potential, not just as an illustrative mechanism (as in fiction) but as one of experience for the performer, participant and viewer. One of the clearest examples can be seen in the installation/performance 'Dolores from 10h to 22h' by New-York-based artists Coco Fusco and Ricardo Dominguez.

'Dolores from 10h to 22h' was staged in 2001 at the Kiasma Museum of Contemporary Art, Helsinki, Finland, and broadcast simultaneously in galleries in Los Angeles, London, and Ljubjlana in Slovenia. The performance 'recreated' the case of Delfina Rodriguez, a worker at a *maquiladora*, or assembly factory, in

Tijuana, Mexico, who was the subject of intimidation and abuse by her employers after attempting to unionise with her fellow workers. The installation was staged in real time, and broadcast using surveillance-style cameras set up as if by the employers. Fusco, playing the worker, was not allowed to leave the room, and the situation of intimidation was played out as Dominguez entered as the employer. Dominguez was able to plan his actions, although online viewers were given a chance to make suggestions – some of which demonstrated, as the performance progressed, viewers' eagerness to see Fusco, the 'employee', abused and humiliated.

The conceptual focal point for the piece is the act of combination – the willingness of the workers to unionise and create an identity that supersedes all of them and acts as a block of becoming, or *haecceity*. This need only be a desire, and Fusco needed only to have that fact related in the conversations that structured the twelve-hour performance. Nonetheless, the performance itself relied on very specific forces being aligned, coming together in this block, in order to *work*. At the heart of this was Fusco's own identity, her own becoming-woman. She does not imitate Rodriguez, but instead she remains Coco Fusco throughout, at least in the eyes of viewers and online viewer/participants. This is crucial to much of the artist's work, especially in her later explorations of the role of women in the War on Terror. These works have seen her take on the role of interrogator, including a video made of her 'training' as a recruit by ex-special-forces interrogation experts. The work relies as much on her abilities as a college professor (whose pedagogic role is clearly defined) as it does her abilities as an actress (to disappear as a person into the role, or to follow orders). Added to this is the industry in which Fusco portrays the situation of exploitation in the maquiladora. The performance was billed by Fusco and Kiasma as dealing with some of the issues of surveillance that entered into the public eye with television game shows such as *Survivor* and *Big Brother*, both

of which involved twenty-four-hour coverage of contestants living together and performing tasks.[13] The performance moved beyond zeitgeist issues of surveillance to engage with wider issues such as the exploitation of maquiladora workers, and this is where the longer-lasting impact of the installation is clear.

The issue of labour and wealth continues to be a problem, and one made worse by the continued expansion of information technology in the office and in the home – as part of work and leisure. In representing the assembly-line workers in Mexico and across the world, and by extending the performance to include online participation, Fusco implicated (and still implicates) the user of technology into the very system that exploits the workers. This counts as much for viewers in the gallery in Helsinki (one of the world's first 'wireless' cities) as it does for viewers on the Internet. Every time we upgrade our computer, television set, DVD player or games console, we participate in a system that is only possible through the exploitation of these workers, and a system that is threatened by acts of combination such as that of Rodriguez. To hear this in a lecture from Fusco as an art professor would seem patronising, since her position is far removed from that of Rodriguez and other maquiladora workers – it is privileged, even. As a performance, however, it uses the contradiction that exists in the technology, the very fact of her own position as a privileged woman, in order to work. Being a woman is not enough; Fusco must become woman by entering into the situation of Rodriguez and others, with the baiting of viewers reflecting the baiting of employers in Tijuana.

The immanence of art

The examples of Mapplethorpe and of Fusco both suggest that it is the particular time and place of the artworks, in intersection with the specific histories of maker or context, that give the art its identity. Artworks, then, are the constructions of much larger forces than one single artist or even one historical trajectory, and

so we need a way of understanding them that expresses this larger agglomeration. Deleuze and Guattari, for instance, pick out in their own work key artists who work with a medium to produce crucial effects – Paul Klee, Wassily Kandinsky and Claude Monet with colour, for example – yet in fact their philosophy of art suits artists for whom the slightest of interventions has been enough to create monumental works. The artist might be an intelligent, skilful and articulate individual, but it is all too easy to adopt a molar position. In fact, the artist's role is one of assemblage, or of putting things together: 'Composition, composition is the sole definition of art. Composition is aesthetic, and what is not composed is not a work of art.'[14] The first position seems fixed in the practice of privileging an artist and his/her particular medium, the second seems to account only for situationist practice, or for the technique of the *étants données*, the ready-made.

In fact, Deleuze and Guattari have a remarkably consistent theory of art that takes into account both positions, and rages against cliché: 'In no way do we believe in a fine-arts system; we believe in very diverse problems whose solutions are found in heterogeneous arts. To us, Art is a false concept...'[15] What gives art practice its constituency, and what gives it a purpose, is this range of problems addressed by art as a multiplicity of methods. What Deleuze and Guattari try to develop is a theory of art that can comprehend its ability to have historical and contextual agency – to have an effect in time and space. This agency is not limited to a particular moment or medium, but is something that they all share.

To start, we can say that art involves simple modulations of form – decisions to put this paint here in this manner, to make that mark there, to divide objects or put them together. As *percepts*, these do more than represent a decision, however, and Deleuze and Guattari subtract (or abstract) the artistic intention. The modulations are much more important than the decisions, since they reveal the forces 'that populate the world, that affect us, that make us become'. When Kandinsky achieves this by 'linear

"tensions"', for example, it means that in drawing a straight line to represent the boundary between colours he expresses the extraordinary forces involved in creating any straight line: physical forces such as gravity, physical tensions such as muscularity, cultural forces from art history and visual culture (even the force of those critics in Kandinsky's mind that must have said that his intention was radical, antithetical, or not proper artistic expression).[16] On the other hand, there are shared, inarticulate feelings that we all seem to know are important, that we feel before we begin to express them. They might account for the fact that, if we strip away culture, history – patriarchy – from so many artworks, they remain great, emotive, extraordinary. These *affects* exist before articulation, yet they are what we describe and share through the exchange of language and ideas; they are what we cling to create our own identity ('We are not in the world, we become with the world; we become by contemplating it.'[17]) even though they are somehow independent of us.

The artist may make decisions, may deal with the forces and materials (percepts), but the intersection with sensation (affects) may never occur or, most importantly, may occur in spite of the artist's efforts. Artworks rely upon the conjunction of percept and affect, when the material 'passes into sensation', and until then they are just clichés or ruminations of the material.[18] Artists therefore are given something of a choice, and their subsequent curiosity is what they bring to the conversation. They can work with the materials and let the intersection occur in its own interval, or they can intervene, often by giving up the material itself and relying only on the movement of forces. This is what conceptual art relies on at its best, especially in performance or situation, since the minimum physical limit of effort is reached just as the maximum conceptual effect is achieved.

In this respect Nicholas Bourriaud, for example, sees the artist as the kind of '*tenant of culture*' observed by anthropologists such as Michel de Certeau.[19] For the artist, the social situation becomes

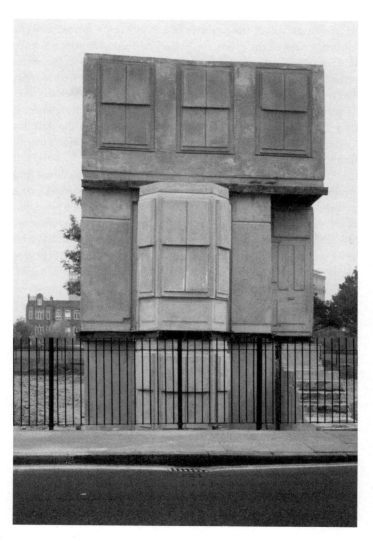

2. Rachel Whiteread,
House (1993).

an essential part of the practice of art, including the political or everyday lives of the artist, the gallery and the studio, the lecture hall and the bar. The artist is a social engineer, trying to foster the situation that will create the event that will in turn produce what Bourriaud calls a 'lasting' artwork.[20] Influenced by Deleuze and Guattari, Bourriaud sees art in the intersection of the material and the cultural, which is almost the same thing for him (but not quite) as percept and affect: 'Art keeps together moments of subjectivity associated with singular experiences.'[21] Bourriaud accepts that this gives the artist an extraordinary political and social agency, to create and foster new relationships, to bring situations together or tear them apart, to intervene in a political, even military, way into world situations. The artist now 'determines the relationship that will be struck up with his [sic] work', and the relations 'between people and world'.[22] This places second, however, the movement of materials, the practice itself, and invites the idea that to be an artist one has simply *to be an artist*.

Perhaps a better proposal is to suggest, as critic-historian Jacques Rancière does, that the artist's practices are '"ways of doing and making" that intervene in the general distribution of ways of doing and making'.[23] The artistic intervenes in the social situation, but art practice itself is a part of that. Artistic practice might involve material decisions – mark-marking, framing, shaping – but *aesthetic* practice is an intervention into these decisions as well as their social condition. An artwork must intervene in art as well as society, it must question the use of materials as well as the culture and situation of the work.

If we look for a good example of this we can find one in Rachel Whiteread's 'House', which was part of her Turner-Prize-winning entry in 1993. As a sculptor, Whiteread's work is focused on percepts, and at that time her work mostly involved casting domestic objects (mattresses, furniture). Situated in the East End of London, 'House' was a cast in concrete of the interior of a

typical Victorian suburban house, which was revealed when the house was demolished (along with the rest of the neighbouring estate). Standing for only a matter of months, it was the subject of both praise and derision, as an artistic intervention into the changing landscape of London and as a social intervention into the diminishing memory of a way of life. The shape and texture of the interior of each room could be seen in fine detail, as had been the case with Whiteread's other works, such as 'Ghost' (1990), the cast of a sitting room. This meant that the sculpture had the same effect as a photograph or home movie, in that viewers were given the sensation of dizzying memory from an almost literal transfiguration of the past onto a solid object. The cast rooms expressed the movements of all the people who have lived in such houses, following and probing the occupation of space simply by filling it up. To touch the concrete was to touch the impression left by the hands of children, adults, workmen, builders, and to touch the traces left from lovers sitting on the window ledge, letters thrown into the fire, of tears at a windowpane.

It was also to touch the experience of Londoners, of Britons, whose lives were given shape by the 'suburban semi'. This is similar to the effect that Whiteread was able to create in her 'Holocaust Memorial (Nameless Library)' for Vienna's Judenplatz in 2000. The negative cast of books can do what few photographs are able to (and there are many photographs of the Holocaust): it can suggest the enormity of the catastrophe by turning lives into books, into novels and the like, whose pages (rather than spines) have left an imprint in the concrete. Whiteread's sculpture, in focusing on the physical shadows left by mundane personal existences, was able to address issues that affected millions. 'House' at first sight might appear to represent monumentality in art as a cliché of sculpture in stone and concrete. Its 'cliché' makes it a useful object, however, with which to investigate the monumentality of artworks: what it is that makes them last in Deleuze and Guattari's terms.

At first glance, their theory of art is expressible in the idea of blocks of sensation – percepts and affects coming together as an intersection created by particular conditions. These are reliant upon the spectator, viewer, critic and maker, in that they reveal the plane of organisation (the movement of materials). What they are really suggesting, however, is that there may be an art that reveals the plane of immanence, the forces themselves whose traces we normally see in the movement of materials. This is when the artist comes closest to the project of the philosopher. Just as the philosopher's task is to remove the strata to appreciate immanence, the forces of life, so artists must remove the contingent or reliant. When Whiteread peeled away the walls of the house that she cast, what was revealed was the space between the cast and the walls; not an open space of materials but the time and space that had been literally inscribed by occupations, by life itself. This is art that is monumental, figuratively and literally. As Deleuze and Guattari relate, art is monumental when it releases us from its formal priorities, including the substance of its making and the social situation within which it sits, and yet simultaneously reveals a truth (political, aesthetic) within the intersection of those things.

Art undoes the triple organisation of perceptions, affections, and opinions in order to substitute a monument composed of percepts, affects, and blocs of sensations that take the place of language… A monument does not commemorate or celebrate something that happened but confides to the ear of the future the persistent sensations that embody the event.[24]

Effectively, true artworks are those that remain, that will speak to the future, speak beyond their own time and place. This is why, for example, Whiteread's 'House' continues to exist even though it has been torn down like the houses around it. Indeed, that is the point of historical irony, whereby truths remain to be revealed, repeated or mirrored. Time will tell whether 'House'

has the real monumentality of an artwork; not the simple monumentality of scale but that of confiding to the future. The fact that some artworks remain current, no matter how hoary or 'lived in' they seem, is because they are still confiding in the future, or perhaps they hold a truth still waiting to be heard. Such artworks are monumental in the same way that a village war memorial or a city's Holocaust memorial is monumental: not because they are large but because they reveal the enormity of a particular truth that will continue to be current.

Part Three

Introduction

What is duration?

It would be fair to say that we all have a pretty good idea what time is. For most of us, time is the way we measure the passing of our lives. Our everyday life is measured in temporal cycles. There are sixty seconds in a minute, sixty minutes in an hour, twenty-four hours in a day, seven days in a week and so on. With this knowledge we are able to get up each morning, calculate how long it will take us to get to school, university or work, usually arrive just a little too late, count the minutes until lunch and so on. These cycles are accumulative, with seven days in a week building up to fifty-two weeks in a year, which in turn builds up in time as every ten years sees the passing of a decade, etc. For most people, then, the experience of time passing is of a *linear progression* through time. This is most obviously so because, each birthday, our age increases by one year, and because every so often we catch a glimpse of a slightly older face in the mirror, or realise that the once easy jog to the departing bus has become a hell-for-leather sprint. Even so, while the above all seems fairly straightforward, Deleuze's view of time is slightly different, due to the influence of French philosopher Henri Bergson (1859–1941) on Deleuze's conception of time. It was from Bergson's notion of duration that Deleuze's work on time in the cinema developed.

Bergson's concept of duration refers to our understanding of time, but not exactly in the usual way. In everyday use we might say that if we went to a football match and stayed until the final whistle then we were 'there for the duration'. 'Duration' is thus

a word we use for a discrete measure of time, and therefore can also have the implied meaning that we are doing something for an inordinately lengthy period of time. For instance, if we were trapped in an elevator with someone who we found rather boring, then we might sigh to ourselves, and again acknowledge that we were 'there for the duration'. In Bergson's case, however, the concept of duration refers to time as an open and expanding whole, that is only understood by humans usually once it has been spatialised, once the flux of time has been fixed into four dimensional coordinates. When this idea was adopted and adapted by Deleuze it led to some startling conclusions as to the way in which time can be represented in cinema.

Before we jump to the conclusion that French philosophers Bergson and Deleuze simply had too much time on their hands and set about overcomplicating matters for the sake of it, it is worth bearing in mind that Deleuze's conclusions were drawn from his observation of the way cinema represented time after World War II. Deleuze was not arguing that our usual perception of time was 'wrong' but, rather, that certain films were suggesting *another way* of thinking about time that had huge ramifications for, among other things, the way in which we imagine our everyday identities.

Bergson and Deleuze

Bergson believed that time was a virtual and ever-expanding whole that he called 'duration'. The major works that defined this concept were *Time and Free Will* (1889), *Matter and Memory* (1896), *Creative Evolution* (1907), and *Duration and Simultaneity* (1921).[1] Bergson's philosophy is broad-ranging and extremely complex, making it difficult to examine any one of his ideas without opening up numerous other huge cans of worms. In brief terms, however, let us now summarise Bergson's view of time and duration.

To begin with, let us focus on the past. In *Matter and Memory*, Bergson argues that memories are not stored in our brains but,

rather, that the past is a virtual store of time. When we remember events from our past, he argues, we travel virtually within this massive virtual vault of past times, seeking out memories and recollections. At the time of its publication Bergson's work was extremely influential, especially in artistic circles. Evidence of the impact of his ideas can be seen in the writings of various authors from around the world, the most prominent of whom was the French author Marcel Proust. Proust's magnum opus, *In Search of Lost Time* (1913–27) both utilised and developed Bergson's ideas to explore the life of its narrator, Marcel (a character modelled on the author) and his life in France before and after World War I. Proust's novel takes Bergson's ideas a step further, and shows how involuntary memory can facilitate a sudden, unexpected leap back into the virtual past. Proust demonstrates how recollections can be brought involuntarily on by smells, sounds, tastes or bodily postures, and uses the example of the taste of a cake, called *madeleine*, which suddenly transports the narrator back in time to memories of his childhood. The continued impact of Bergson's ideas on the literary mind is evident today, with Ian McEwan's *Atonement* (2001) clearly showing evidence of a Bergsonian view of time. In fact, although the idea that we are all time travellers within a giant virtual memory bank was most easily transferred to literature during Bergson's lifetime, with the growth of the visual media during the twentieth century the most obvious place to look for artistic representations of duration are now cinema, television and various new media (e.g. the Internet and computer games). For instance, during a flashback in film, television or even a video game, the viewer or gamer is transported into the virtual past of the narrative, often – as we shall see further in Part Three – in a Bergsonian manner.

Let us provide some more depth to Bergson's view of time. Bergson theorised that the virtual past was ever-expanding. At each moment in time there was a division of time into what

Deleuze would later come to call 'a present which is passing and a past that is preserved'.[2] The present moment is experienced by us in the actual day-to-day things we do. The past is an image of these day-to-day actions, which is stored in its virtual form. At every moment in time, then, there is an actual and a virtual version of everything we do. When we try and remember the past it is among the stored virtual images of the past that we seek. When the past interrupts our daily life unbidden, for instance when involuntary memory 'flashes' us back to the past, it is often because our actual present (a taste, a sound, a smell, a physical posture) matches a virtual image stored somewhere in our virtual past. It is, therefore, to this part of the virtual past (which Bergson imagined to be shaped like a huge cone[3]) to which we are transported. The sense of a continuous present, on the other hand, occurs because we are conscious of the actual version of our activities that occurs in the present. It is here, in space as much as in time, that we normally perceive the linear progression of time passing.

In *Creative Evolution* Bergson develops upon his notion of the past and argues that the whole universe is constantly expanding. As Bergson puts it: 'The truth is that we change without ceasing.'[4] Correspondingly, as the universe exists in time, time is also an ever-expanding whole: duration. The following quote summarises his stance:

Duration is the continuous progress of the past which gnaws into the future and which swells as it advances. And as the past grows without ceasing so there is no limit to its preservation. Memory … is not a faculty of putting away recollections in a drawer, or of inscribing them in a register. … (I)n reality the past is preserved by itself, automatically.[5]

For Bergson, then, the past is preserved virtually, constantly being added to as each moment in time creates a new 'image' to be added to the store of the past, or remembered, 'automatically'.

Moreover, the weight of the virtual past is constantly pushing time onward into the present, each new image that is added to the past, building up the momentum that enables time to 'gnaw' into the future.

Observing time from this point of view, Bergson concluded that when we observe change, we usually do so by measuring the difference between a present and a past state. This is easy to imagine if we take a common example. Looking back at photos of ourselves as children, we can immediately see the difference between ourselves then and ourselves now. Change is easy to see, then, when we compare actual states. It is much harder to capture and measure the continuous process of change, however. In effect, when we measure time's passing we spatialise duration, creating 'cut-out-and-keep' images that we can compare in order to conceive of change. Even so, Bergson maintained that there was a continuous process of change taking place in the time between these apparently measurable states. Thus what we perceive as actual reality is really a snapshot or freeze-frame of the perpetual process of virtual becoming that is duration. We measure time by spatialising it.

In *Cinema 1* (1983) and *Cinema 2* (1985), Deleuze develops his work on Bergson. Put briefly, unlike Bergson, who was sceptical about cinema's ability to render visible duration, Deleuze feels that certain films are able to render visual the passing of time of duration; these he calls 'time-images'. On the other hand, he argues, there exist 'movement-images'. These are also able to record the passing of time, but only by spatialising it into blocks of space-time. The time-image is a glimpse of time in and for itself, of duration. The movement-image, on the other hand, helps us understand how the virtual whole of time is spatialised by consciousness as we attempt to make sense of our daily lives.

Chapter 5

Movement-images, time-images and hybrid-images in cinema

David Martin-Jones

In his cinema texts *Cinema 1* (1983) and *Cinema 2* (1985), Deleuze uses cinema to argue that our conception of time changed in the twentieth century, particularly after World War II. To illustrate this shift in thinking, he identifies two broad categories of image, the time-image and the movement-image. In this chapter I first introduce each of these categories of image using well-known examples. I then analyse a recent film, *The Cell* (2000), to briefly show how and why these two categories have increasingly begun to intertwine since the end of the twentieth century.

Movement-image

In *Cinema 1*, Deleuze argued that certain types of films existed that could be classified as movement-images. He identified several different types of movement-image, from France, the Soviet Union and Germany, but the most typical was the action-image of the classical Hollywood film. I focus on this type of movement-image from now on, as it provides the clearest example of Deleuze's ideas.

Deleuze chose the term 'movement-image' to describe films in which time was subordinate to movement. In this style of filmmaking, time was rendered indirectly. Put another way, time was edited to fit the story. Now, it does not take a famous philosopher to observe that, in cinema, time is condensed. As viewers, we expect the events of several days, weeks or years to be rendered in a recognisable time span: ninety minutes for a mainstream film, two hours for an art film,

and three to four for a Bollywood film. There is more to it than this, though.

For Deleuze, the passing of time in the movement-image is focused around the movement of the protagonist, and becomes spatialised in the process. This is because, in the movement-image, rendering visual the passing of time is a secondary concern to the telling of the story. As an example, consider *Die Hard* (1988). *Die Hard* depicts one hellish night in the life of New York City cop John McClane as he battles armed robbers in the Nakatomi Building, Los Angeles. This night is reduced to the length of an easily digestible feature film, as time is edited to fit the story. The story focuses on McClane's activities, linear temporal continuity being maintained by this focus on the protagonist. No matter how many different spaces McClane variously runs, jumps and explodes through (from bullet-strafed offices, to cramped air ducts, to perilous lift shafts, to death defying leaps from the roof of the skyscraper), the story remains focused on McClane, and the passing of the night is rendered visible by his increasingly battered physique.

Thus, although the movement-image appears to provide the most commonsensical, direct image of time, in actual fact it provides an indirect expression of time. Time in the movement-image is not only condensed, it is also spatialised, rendered visible only as a product of the time it takes for a protagonist to act. Indeed, it is the ability of the protagonist to act that facilitates the passing of time in the movement-image. When protagonists of a movement-image encounter a situation that necessitates that they act, they are able to do so, and through their actions the situation is resolved. In *Die Hard*, McClane uses his police training, death-defying courage and brute masculinity to overcome the threat of the technologically superior robbers. Thus the trajectory of the movement-image is typically from situation, through action, to changed situation, a trajectory that is propelled by the ability of protagonists to act upon what they see. The movement-image,

then, is characterised by action based around protagonists whose sensory-motor continuity (their ability to act upon what they see) is unbroken. This facilitates the construction of a linear story that can traverse any number of varied spaces, with continuity being provided by the protagonists' active presence.

Time-image

In contrast to the movement-image, Deleuze offers the time-image. He argues that certain films, especially several that emerged from western Europe after World War II, provide evidence that our conception of time is changing. In the films of art cinema directors of the 1960s and 1970s – such as Alain Resnais and Jean-Luc Godard from France, or Federico Fellini and Michelangelo Antonioni from Italy – Deleuze detects a new and different conception of time.

In the time-image, the passing of time is depicted in its own right. It provides a direct image of time. At the most extreme level, we could consider a film such as Andy Warhol's *Empire* (1964), which depicts the Empire State Building in a static shot over the course of eight hours. Here the action is not condensed in any way, and the patient viewer is able to experience the passing of time, as it were, in 'real time'. This is an extreme example, however. For Deleuze, the emergence of the time-image began in post-war European cinemas, like that of Italian Neorealism in the late 1940s. On the first page of *Cinema 2*, Deleuze provides a prime example in a famous scene from Vittorio de Sica's *Umberto D* (1952). This scene has been variously discussed by critics as diverse as André Bazin in 1953 and David Bordwell and Kristin Thompson in 2003.[1] In this particular scene, Maria, a pregnant maid, wearily trudges through her daily chores, including lighting the stove and making coffee.[2] In a Hollywood film this type of scene would probably never be shot, but even if it were the moments of 'dead time', in which Maria sits and contemplates her pregnancy, would most likely hit the cutting-room floor. Here, then, is an excellent

example of the way time-images record the passing of time in and for itself, rather than editing out moments of time deemed extraneous to the development of the narrative of heroic individuals.

On another level, the time-image is able to represent the virtual whole of time found in Bergson's duration. In *Cinema 2*, Deleuze combines Bergson's model of the virtual whole of time with the concept of the labyrinth of time found in the fictional writings of Argentine author Jorge Luis Borges.[3] The resulting model is that of a labyrinth of virtual pathways through time. As individuals we only ever know the one pathway that we live, the one that solidifies and becomes actual around us. An infinite number of other possible timelines exist in a virtual state, however, and each one becomes actual elsewhere – or, rather, 'elsewhen'. Nowadays this model of time is well known to fans of science fiction, parallel universes being a staple of television series such as *Star Trek: The Next Generation* (1987–94).

For Deleuze, this model of time was typically manifest in two ways, which he called 'Peaks of Present' and 'Sheets of Past'. Films that delve into the past in a Bergsonian/Deleuzian manner include *Citizen Kane* (1941), and numerous films by Federico Fellini such as *8 ½* (1963), *Roma* (1972), *Amarcord* (1973) and *Intervista* (1987). As a more contemporary example, in 1999 Chilean director Raoul Ruiz made a film of Proust's *Time Regained* in which the protagonist, Proust the author, lying dying in bed, moves virtually through the stored past in search of lost memories. Here the time-image is clearly seen, as an incapacitated protagonist (unable to act decisively and affect his situation for the better) instead travels between the sheets of the past, enabling the viewer to catch a glimpse of the virtual whole of time.

On the other hand Deleuze observed the existence of time-images that also capture the virtual existence of duration directly, but do so by focusing on the moment in the present when time splits. Here the definitive example is Alain Resnais's *Last Year at*

Marienbad (1961), a film that replays a meeting between a man and a woman that takes place during a dinner party.[4] Various contemporary films can also be viewed in this way, including the German hit *Run Lola Run* (1998). *Run Lola Run* replays the same story three times (that of its protagonist's desperate attempt to obtain DM100.00 in twenty minutes flat in order to save her boyfriend's life), each time with a different conclusion. In this sense it perfectly expresses the notion that the same event takes place an infinite number of times in infinite parallel universes. In Deleuze's words, it evokes the 'simultaneity of presents in different worlds' that exist if we conceive of time as a virtual labyrinth.[5]

In the time-image we encounter a fundamental confusion over the truth. Take the flashback, for instance. In the movement-image, flashbacks often appear in order to provide an answer as to why events in the present are taking shape in certain ways. It is not uncommon for this type of flashback to be used to reveal a psychological trauma from the past, which can explain a character's motivation in the present. The classic examples of this type of flashback can be found in Alfred Hitchcock's films, such as *Spellbound* (1945) and *Marnie* (1964). In the movement-image flashbacks make clear the causal link between the past and the present. They reaffirm a straightforward view of time as a single, linear trajectory. In the time-image, by contrast, delving into the past often causes greater confusion. In *Citizen Kane*, for instance, different perspectives are offered on the life of Kane, illustrating the subjective nature of truth. He was different things to different people. Similarly, in Fellini's films the past is rarely a place where solutions are found. Rather, explorations of the past demonstrate how many contradictory or confusing versions of the past exist in the virtual labyrinth of time. As Anna Powell has recently pointed out, this type of confusion between past and present is often deployed to terrifying effect in horror films, especially in haunted house movies such as *The Shining* (1980), *The Haunting* (1999) and *The Others* (2001), where different

layers of the past coexist with, and continue to influence, the present.[6] Accordingly, editing in the time-image is often discontinuous, linking together unconnected spaces or regions of the past in a way that deliberately creates confusion in the mind of the spectator. In the time-image, then, our certainty as to the truth of what has happened in the past, what is happening in the present and what will happen in the future is always questioned.

Hybrid-images

Deleuze's categorisation of images poses one important question: exactly why are some films movement-images, and some time-images? At the beginning of *Cinema 2* Deleuze mentions World War II as a dividing line between the 'classical' conception of time found in the movement-image and the 'modern' vision of time of the time-image. He does not elaborate on why World War II marked this break in any great detail, however. At this stage, then, let us briefly consider some of the possible reasons for the emergence of time-images and movement-images at different times in the last century.

At an industrial level, the reason for this division appears fairly clear. The rules for continuity editing created and refined by the Hollywood studio system in the early decades of the twentieth century were designed to ensure complete clarity of narrative for the viewer. For this reason, the movement-image became dominant, as the 'reality' of time's passing was subordinated to the telling of the story. On the other hand, since the end of World War I the European film industries have attempted to create distinctive cinematic styles that can compete – albeit with niche audiences – in a marketplace dominated by the universal appeal of the Hollywood product. To do so they often utilise aspects of avant-garde modernist artistic traditions peculiar to certain European countries, several of which, including cubism, surrealism and expressionism, experimented with time in a variety of ways. In the aftermath of World War II, then, the

emergence of time-images in the art cinemas of European countries such as Italy and France can be interpreted as attempts to create a different type of narrative from the Hollywood movement-image. This is certainly one reason why the time-image was born.

An industrial dimension is never enough on its own, however. Like all films, movement- and time-images can be interpreted in any number of other ways. What about their content? Deleuze notes that post-war Europe was marked by a proliferation of what he calls the 'any-space-whatever', spaces where people no longer knew how to react to their situation.[7] Although he never said so particularly directly, Deleuze saw the effect of the war on Europe reflected in the inability of protagonists of the time-image to influence their situation positively. By contrast, the cinema of the now triumphant superpower the United States had no such problem; hence the Hollywood movement-image was populated by individualistic heroes who had no difficulty reacting to their circumstances. We are now getting closer to understanding why time-images and movement-images appeared where and when they did. Put in simplistic terms, many European countries were damaged by the war, not only economically and physically, but also psychologically. The primacy of the colonialist central European nations on the global stage was suddenly superseded by the emergence of two superpowers (the Soviet Union and the United States) in the ensuing Cold War. Time-images emerged in these nations as they looked back into their pasts, questioning the truth of their identities as they began to rebuild after the war.

Why, then, are there so many hybrid-images now? Why are there so many films that contain aspects of both movement-image and time-image? Again, the most obvious place to look is the marketplace. With an increasingly global market to aim at, national film industries, film studios and independent filmmakers know that films that can cross over between mainstream and niche markets (such as the art cinema distribution network) can

make a great deal of profit. Some high profile examples of this approach include *Groundhog Day* (1993), *Pulp Fiction* (1994), *Sliding Doors* (1997), *Run Lola Run* (1998), *Being John Malkovich* (1999), *Memento* (2000), *Irreversible* (2002), *Eternal Sunshine of the Spotless Mind* (2004) and *50 First Dates* (2004). All these films contain the basic elements of the movement-image, but have also incorporated aspects of the time-image (most usually in the form of a repeated, jumbled or otherwise disrupted narrative time scheme), therefore guaranteeing maximum market appeal. They use clearly defined genres and recognisable stars to appeal to mass markets, but also experiment with narrative time in order also to appeal to a more 'intellectual' art cinema crowd.

Once again, however, there is more to this than money, as at least two critics have noted. Patricia Pisters' *The Matrix of Visual Culture* (2003) examines films with characteristics of both time- and movement-image as expressions of a new age, where 'a new camera consciousness makes clear distinction between the subjective and the objective impossible; [and] the past and the present, the virtual and the actual have become indistinguishable'.[8] For Pisters, these hybrid films are evidence of a broader historical shift. As contemporary popular culture becomes increasingly image-oriented, even Madonna's music videos (Pisters analyses *Don't Tell Me*) begin to represent what Deleuze called 'the crystal of time', the indistinguishable existence of time as both virtual and actual images.[9]

David Martin-Jones takes a slightly different tack in *Deleuze, Cinema and National Identity* (2006), interpreting films such as *Sliding Doors*, *Run Lola Run*, *Memento* and *Eternal Sunshine of the Spotless Mind* as expressions of national identity. For Martin-Jones, the fractured temporal narratives of these films visualise recent disruptions to the narrative of national identity, a process that the films then attempt to work through to find the most profitable trajectory available to both the film's narrative and that of national identity.

For the remainder of this chapter I examine one hybrid film, *The Cell* (2000), which provides evidence of all three of the above reasons behind the proliferation of the new hybrid image. These are seen in its use of movement- and time-image to appeal to larger markets, its acknowledgement of a new era of 'camera consciousness' in which actual and virtual become indistinguishable, and its subtle examination of the effect of this new era on questions of national identity.

The Cell (2000)

The Cell is a mixture of science fiction film and serial killer thriller. It focuses on experimental psychoanalyst Catherine Deane (Jennifer Lopez), who is part of a team of US scientists attempting to explore the human mind. Deane is introduced in a sequence that appears to have the logic of a dream, in which she talks to a

3. *The Cell*
(2000).

troubled child. It soon transpires that Deane's body is actually wrapped in a sexy, space-age, red rubber virtual reality suit with a 'neurological synaptic transfer system' face veil, and suspended from hooks in the ceiling in a laboratory alongside the comatose body of the boy. Through unspecified high-techery the neurological synaptic transfer system enables her to tune into the mind of another. Her consciousness is thereby able to travel into the boy's mind. When the story of the FBI hunt for a disturbed serial killer Carl Rudolph Stargher (Vincent D'Onofrio) is introduced it is only a matter of time before Deane is hooked up to the mind of the killer, exploring his mind for clues as to where his final victim is being held. Stargher is a schizophrenic who was violently abused by his father when a child, and who has consequently developed into a pathological killer. He kidnaps women, drowns them, bleaches them to look like dolls, and then suspends himself over their corpses by metal chains attached to hooks in his flesh in order to derive auto-erotic pleasure. When the FBI catch him, however, he has already slipped into a coma, and the only way of saving the final girl he has kidnapped is for Deane to enter his deranged mind.

Throughout *The Cell* there is a clear distinction drawn between the physical world, which is conventionally rendered as a movement-image, and the mental world, which follows the unusual logic of the time-image. Like any Hollywood thriller it has a clearly defined deadline (in this instance, the need to save the trapped girl before she drowns), it focuses on the actions of its active masculine protagonists – especially the bodies of well-trained FBI agents breaking down doors, examining crime scenes, driving cars, and flying in planes and helicopters – and the editing is conventional in its manipulation of time to suit the bodies of these men as they rush to meet their deadline. On the other hand, the film also contains numerous aspects of the time-image. Deane and her patients are physically suspended so that they cannot act, allowing Deane to travel virtually within the minds of others. On

entering the mind the editing suddenly becomes discontinuous, as a range of bizarre landscapes are introduced to represent the workings of the mind. Here we have obviously moved from movement-image to time-image. In this respect, *The Cell* illustrates the way in which the movement- and time-image typically interact in contemporary cinema. Although both types of image appear in the same film, the time-image is used to explore the inside of the mind, while the movement-image is equated with the activity of the body. Other examples of this type of hybrid include *The Matrix* (1999), *Being John Malkovich*, *Mulholland Dr.* (2001), *Identity* (2003), *Gothika* (2003), *Eternal Sunshine of the Spotless Mind* and *The Jacket* (2005).

In terms of its market orientation, the film could be described as an MTV-inspired *Silence of the Lambs* (1991). It takes the serial killer genre into new territory by employing the time-image in a manner that is similar to the MTV music video. Once inside the mind of the serial killer the imagery becomes all important, as we are given clues to the psychological reasons for the killer's actions through disturbing tableaux: of a horse standing in a room that is suddenly dissected by a falling glass cage; various imprisoned dolls, women and doll women; people in water tanks; medieval torture scenes; impressive throne rooms and bedchambers; and the recurring image of the young Stargher's baptism from which his schizophrenia stemmed. In this respect the film is akin to music videos that use striking images to accompany a song. Thus the film uses its hybrid format to reach a broad audience of both serial killer fans and the bigger teen market of the MTV generation. Similarly, the casting of its major star, Jennifer Lopez, is a strategic ploy, as she was well known as a pop star before she turned to acting. When watching her in the mind of the serial killer it is almost as though we are watching a music video – as her body is variously imprisoned in a small glass box at the top of a perilous tower, catapulted upwards only to hang suspended by a rope around her ankles, falls into a slow-motion dive, is brought to

rest, suspended in mid-air with dark hair billowing as she telepathically communicates with an albino Alsatian dog – all the time effortlessly changing costume, from everyday casual dress, to flowing red robes, to elegantly patterned transparent black dress.

The choice of Tarsem Singh as director is telling in this respect. His previous credits included director of the music video for R.E.M.'s hit song, *Losing My Religion*. In the R.E.M. video, shots of the band are punctuated by tableaux depicting figures in 'exotic' historical costumes drawn from artistic and biblical sources, and imprisoned and bound bodies, including Saint Sebastian tied half-naked to a tree and penetrated by arrows. At times the images in *The Cell* seem extremely similar, as though Tarsem has remade this particular video in order to fit the major themes of this feature film, and with a much larger budget. Finally, in an attempt to appeal to this broad demographic, the theatrical trailer for the film makes excessive use of the most striking images from the time-image sections, focusing especially on J-Lo in her various costumes and bizarre settings. Much as a music video can be considered a promotional shop window for a song that a record company is selling, so too here does the film's incorporation of the time-image – in this instance deployed in ways that are reminiscent of a music video – also function as eye-catching advertising for the film.

The Cell also illustrates very clearly Pisters' contention that we now exist in an era marked by a camera consciousness, most clearly because the workings of the human mind are depicted exactly in the manner of an MTV music video. Pisters argues that in the slightly earlier film *Strange Days* (1995) – where people are able to enter the recorded memories of others through a virtual reality device called a 'squid' – 'the brain has literally become the screen' on which it is impossible to tell reality from illusion.[10] In *The Cell*, once inside the schizophrenic mind of the comatose Stargher it is similarly impossible to distinguish between fantasy and reality, past and present (Stargher's childhood exists alongside

his murderous adulthood), and virtual and actual. This hybrid image, like those that Pisters discusses, is also evidence that we live in what she calls the 'matrix of visual culture', an image-oriented world where our existence is increasingly determined by the reality of images, or, rather, the indiscernibility between reality and images.

Finally *The Cell* demonstrates Martin-Jones' observations concerning the way in which such hybrid films use a disrupted narrative time scheme to negotiate transformations to national identity. In this film the increasing intrusion of scientifically constructed surveillance into contemporary US society is made to appear reassuringly 'safe' through the story of a caring psychoanalyst who willingly enters the minds of others in order to help them. Emerging in 2000 – noticeably before 9/11 raised the issue of homeland security as a major concern in the United States – *The Cell* shows a combined team of FBI and top scientists, using equipment that effectively has the power to control people's minds. Significantly, *The Cell* shows this technology being used only for 'good'. Unlike the damning portrayal of the way the media manipulates people's minds seen in *Strange Days*, *The Cell* suggests that powerful companies pursuing scientific research into various ways of controlling thought, and state-run institutions such as the FBI, are all part of the same protective milieu.

In *The Cell*, the time-image is very much 'contained' within the film, used only to show the 'illogical' workings of the mind. The discontinuous spaces of the killer's mind are mapped by the psychoanalyst Deane, and eventually also by FBI agent Peter Novak (Vince Vaughn), in order to save the killer's last victim. These two characters from the 'real' world of the movement-image are thus able to triumph over the 'chaos' represented by the time-image, ensuring that the movement-image, which still dominates the US mainstream, retains its normative status. The spatialised view of time seen typically in the movement-image is finally

transcendent over a potentially destabilising rendering of time in its pure state, of the confusing layers of time of duration.

Deleuze situated the appearance of the time-image in the period immediately after World War II. This suggests that it was a form of expression in European countries whose previous sense of a continuous national identity had been interrupted by the war, their disrupted narratives almost literally representing the suddenly disrupted national narrative of these nations. Throughout the Cold War, and as the United States maintained and then strengthened its global dominance after World War II, Hollywood has retained the movement-image as its dominant form, even though the time-image occasionally appears in avant-garde or independent films. Thus, when the time-image does begin to appear more in films such as *The Cell*, it is interesting to see that it remains a controlled instance of the time-image, rather than a force with the potential to disrupt the overarching linearity of the film. The time-image is introduced to show how effectively the United States (through its industry and its security personnel) can control any threat to disrupt its dominant image of national identity.

The fact that Deane's body, with a little help from FBI agent Novak, is able to map the spaces of the time-image is significant. Even in the movement-image, discontinuous spaces appear, as in *Die Hard*, but the consistent appearance of the protagonist helps the viewer map these spaces by focusing attention on his/her ability to act. Even when it veers into the territory of the time-image, then, *The Cell* retains a role for the character from the movement-image, who guides the spectator through the discontinuous spaces of the killer's mind. With the possible exception of *Eternal Sunshine of the Spotless Mind*, of all the films mentioned above that represent the actual world with the movement-image and the mental world with the time-image, few feel secure enough to allow free reign to the confusion that can be caused by the time-image.

Despite these three major ways in which we can understand the increased appearance of images that contain aspects of both time-image and movement-image, a word of caution is necessary. Both Pisters and Martin-Jones acknowledge the dangers of assuming that all such films are equal. In fact, even during the most bizarre moments when we travel through a killer's mind in *The Cell*, the time-image is constrained to ensure that it does not endanger the legitimacy of the movement-image as the dominant form of image; most obviously, when the time-image is incorporated it is used to represent the workings of an ill or deranged mind. This is an extremely conventional construction for Hollywood, where a confusing or frightening mental state is often introduced using a cinematic style that contrasts with that of the movement-image. This was the case, for instance, in Hitchcock's *Spellbound* (1945), which contained a surreal dream sequence originally designed by Salvador Dalí.[11] It is no coincidence that Stargher's comatose state is described as 'like having a dream and never waking up'.

In *The Cell*, the final deadline for saving the girl retains the linear progression of spatialised time of the movement-image, while the direct image of time of the time-image is deployed as a moment of spectacle within an otherwise conventional narrative. As Deleuze noted of Fellini's films, in the time-image the child and the man exist contemporaneously as the protagonist searches through the different layers of his past. For Deleuze this coexistence entailed the possibility of eternal rejuvenation, as 'the past which is preserved takes on all the virtues of beginning and beginning again'.[12] In *The Cell*, by contrast, Deane discovers the child and the man coexisting in the killer's mind, but is able to 'cure' Stargher by helping the boy. After Deane wounds the monstrous adult Stargher, the boy Stargher leads her to the imprisoned girl, and (after she allows Stargher to visit her in her mind) when Deane cures the little boy Stargher in a baptism ritual the monstrous adult side dies for ever. Rather than the potential

for endless change offered by the virtual coexistence of child and man in duration envisioned by Bergson, Proust, Deleuze, Ruiz (etc.) in the time-image, *The Cell* reterritorialises time into a straight line by positing a psychoanalytical origin for the killer's present state in the past. By helping the boy, Deane effectively realigns time into a linear continuum that is rendered as though it were a cure. This suggests that there is only one 'right' version of the past, and destroys any confusion between coexisting past and present (child and man), and any further potential for change.

Chapter 6

Time (and) travel in television

Damian Sutton

Up to this point, we have looked in particular at the plasticity of representations of time in cinema – formations or structurations of time created through the filmmaking process and its developmental history. Even now, with the advent of split-screen television and film, and with ever more sophisticated methods of film narration, the idea of time as a logical, linear progression is hard to resist. Indeed, British TV shows such as the BBC's *Hustle* (2004–), or the hugely successful US Fox show *24* (2001–), have gone a long way to represent a singular, fixed, contemporaneous time through which we all live. When we see slow-mo events, or actions crossing each other in split screen, the simultaneity expressed reveals one world, one narrative, *one time*. On the other hand, flashbacks and non-sequential narratives have remained as contemporary staples of cinema and, especially, television. Television shows such as CBS's *Crime Scene Investigation* (2001–) in the United States are predicated on flashbacks to reconstruct the various theories of the police investigations, as is the case with many detective shows. Similarly, Warner Bros' presidential drama *The West Wing* (1999–2006) often used discontinuous narrative to develop the backstory to each character's history of involvement with the incumbent president, often at times of national crisis, or to give analysis to a complex political manoeuvre.

So, if television shows carefully develop a clear sense of time as a linear progression, even to the extent of following a particular day per episode (*The West Wing*) or even a day per season (*24*), how

do they successfully maintain a sense of past and future that is able to interrupt and even inform present actions? Perhaps the answer lies in Deleuze's ideas about our experience of time itself, and in particular his reliance on Bergsonian ideas of memory as a kind of sensation of time. Deleuze was perhaps most influenced by Dutch philosopher Benedictus de Spinoza (1632–77), though the legacy of his work on Bergson can be seen in so much of his philosophy, especially in trying to understand how it is that we conceptualise the continuously changing situation in which we live. For while Spinoza gives Deleuze the notion of immanence, it is Bergson's idea of duration that effectively sparks in him the development of a philosophy of time. The debt to Bergson is so strong that Hardt has suggested that Deleuze's dealing with Bergson really began his 'apprenticeship in philosophy'.[1]

First, however, we need to consider how we organise time. For Deleuze, the kind of time that we turn into history does not exist. Indeed, we can only ever live in the present, the infinitesimally small moment that divides past and future. There is no 'real' past into which we can travel. *Even to read the last sentence a second time would not give us again the exact experience* – we have changed irreversibly even in the small time it takes for all the electrons in all the atoms in all our molecules to achieve one rotation. So, if we do not live in the kind of time that we imagine as linear and sequential, then what do we live in and why do we create time as its image? TV shows such as *Lost* and the recently revived BBC show *Doctor Who* (1963–89, 2005–) have very different approaches to this, taken from different points of view of our construction of time. For the characters in the US show *Lost*, there is a collective here and now with pressing need and demands, which is informed by the personal past of each individual. They will illustrate for us the past as memory in a virtual coexistence. For the characters in the BBC's long-running *Doctor Who*, however, it is time on a fundamental level and on a grand scale that they explore.

Doctor Who's body without organs

Consider what it means to organise our time. We create organs out of elements of our lives, like organs in a body, which work and function together. For instance: we make a list of things to do this day, giving it a logical and rewarding internal structure. This relies on a given set of situations, however, based on agreement as much as nature. So, a unit of time we call a 'day' requires a night beforehand and afterwards: the turning of the Earth and the rotation around the Sun. It also relies on a certain amount of our own wilful ignorance: to make sense of our day we need to ignore the fact that at midday in London it is already late afternoon in Baghdad, early morning in Washington DC.

This organisation of time is essential to time-travel narratives, such as those in *Doctor Who*. For instance, the travellers' technology is often out of place, such as the ghetto blaster that turns up in 1963 in 'Remembrance of the Daleks' (1989). In this case we are reminded that, no matter how far the Doctor travels, he is always in our present, and the ability for past, present and future to coexist is established with considerable ease. In other cases, it is alien technology that appears futuristic to us, when it is transplanted into Victorian London in 'Evil of the Daleks' (1967), Restoration London in 'The Visitation' (1982), or 1930s New York in 'The Daleks in Manhattan' (2007). With time measured by culture and society, in the universe of *Doctor Who* we have to remember that at midday on Earth it is early morning on the planet Skaro and late afternoon on the planet Telos.

If we return to our regular Earth day, perhaps most significantly, the day we plan requires a whole system of labour exchange to turn our effort into quantifiable study or quantifiable work, into eight hours of labour that will 'earn' us five hours of free time before the day is out. This is a 'day' that gives figural shape to time, an organ within a body of organs (days–weeks– months, years–decades–centuries) that is time as we understand it. If we took all this away, we would have chaos.

Or would we? In an episode of the 2007 season of *Doctor Who*, 'Blink', the Doctor (David Tennant) is asked to explain time and how it works. This is because he has recorded a message in the past to Sally Sparrow (Carey Mulligan), a person in the present, via a video playback that appears to be 'live'. What should happen is that the message be sent (like a message in a bottle) in a one-way direction, since it is not possible for us to interact with a video playback. The Doctor seems to interact with Sally as if answering questions, though. In fact, a transcript of the conversation will be given to the Doctor in the future (he is, of course, a time-traveller) in the knowledge that he will become trapped in the past while trying to defeat a group of monsters called 'the weeping angels', living statues who kill by touching people and throwing them back in time to live in the past. The Doctor's method of escape (and the defeat of the angels) is therefore to set in motion the events that lead up to Sally discovering the video disc and thus the message, often by contacting people she knows have disappeared. They relay instructions to her when they meet her as old people. This piece of time-travel fantasy appears, from the outset, to have a neat circular logic, yet what has happened is that the limits that we set on our organised time have been broken. A distinct sense of the past (the video message) exists, but becomes indistinguishable from the present, which is the future of the Doctor from a position that he knows is the past for Sally. What this illustrates is that, when we take away organisation, we are not left with a chaotic structure but, instead, one that actually allows a remarkably smooth transition from past to present and back again. All the aspects of time – past, present and future – are revealed as one time:

The Doctor: People assume that time is a strict progression of cause to effect, but actually from a non-linear, non-subjective viewpoint it's more like a big ball of wibbly-wobbly, timey-wimey ... stuff.[2]

This idea of time as a 'non-linear, non-subjective' entity is what Deleuze and Guattari would call a body without organs, or BwO.

Introduced in *Anti-Oedipus*, the BwO could be seen as Deleuze and Guattari's way of understanding pure substance, such as the human body (the person who becomes a subject) as well as the collective body of society, the *socius*, which becomes a people.[3] The principle is the starting point for understanding the personal and social subject. The method of analysis they call schizoanalysis, which understands the individual or social subject as collections or aggregates, stems from the BwO.

The BwO is, for Deleuze and Guattari, a presupposition of identity. Famously, Deleuze and Guattari's task, spread across the mammoth two-volume work of *Capitalism and Schizophrenia*, is to provide an alternative, dynamic way of understanding identity that resists the rigid Oedipal structure of psychoanalysis. Where psychoanalysis begins with the binary-linear relationship of child and parent, Deleuze and Guattari uncover a third position – the BwO – that exists in triangulation. This is the body that will become identity, waiting to be created as a body over time, coagulating and shifting only as a kind of inevitable 'glacial reality': 'You will be organized, you will be an organism, you will articulate your body…'[4] The subject is formed over time, and the impression of self as fixed (as one's true self, for instance) is in fact a misunderstanding of the way that the subject exists and changes in an awesomely slow path through time.

As a presupposition, the BwO exists before organisation, and the immediate tendency is to think of it as chaotic or even as an empty space. This could not be further from the truth, however, and it remains filled with energies and forces, along with the matter. The BwO is thus both desire and potentiality, an *awaiting*. Furthermore, it is predestined to organisation – it coalesces into shapes – and so the best way to understand it in its purest existence is as *smooth* at both beginning and final state. Political/economic structures, for example, organise the body of the socius in order to create their own smooth shapes: capitalism, for example, is a system that tries to convert all value into an

exchangeable currency that can be moved and redeployed at will. In our lives we are paid for our labour in money that can be converted to any currency, that can buy objects created by others, and can even buy the value of others' labour: 'Capital is indeed the body without organs of the capitalist, or rather of the capitalist being.'[5] As we found earlier, the economic philosophers Hardt and Negri have linked the smoothing effect of capital to the development of a worldwide economy. For them, the 'general equivalence of money brings all elements together in quantifiable, commensurable relations ... Capital tends toward a smooth space defined by uncoded flows, flexibility, continual modulation, and tendential equalization.'[6]

The body without organs is a presupposition of form and meaning, and thus the closest Deleuze ever comes to a figural description of immanence. A smooth space of pure movement and transition, it is impossible to conceive of without the process of organisation that will create shapes from it: the smooth space of the BwO is itself irresistible. What matters then is its relationship to organisation, both of the personal and social bodies, and time is marked out by the machine-like creation of a body or a social system. This is why Deleuze and Guattari are also drawn to the machine from the very first pages of *Anti-Oedipus*, since the machine is an assemblage of parts, an organisation of the body, which produces its own production as much as it produces movement or objects. (Humans are not made up of bodies and minds but are desiring-machines.) The principle of the machine is what throws the socius toward a smooth state of the political system, for example, which remakes itself after every cataclysm. This is what happens in an episode of *Doctor Who*, 'The Girl in the Fireplace', in which the Doctor and his companions Rose (Billie Piper) and Mickey (Noel Clarke) find themselves on a spaceship that has opened a time window to eighteenth-century France. Here, the sequentiality of time itself is broken as bulkheads reveal various points in the life of one person, the real Madame

de Pompadour (Sophia Myles). Clockwork robots service the station after it is nearly destroyed in an ion storm, and they repair the station using the real organs of the injured crew (an eye for a camera lens, a heart as an electrical relay). They are awaiting the moment when Reinette, Madame de Pompadour, reaches a certain age in order to use her brain as the station's central computer. The story is fantastic, and held together by the Doctor and Reinette as eventual lovers meeting throughout her life, as he steps in and out of the station's bulkheads. As with 'Blink', which shared the same writer Steven Moffat, the tragedy of the story is provided by the varying speeds of the two 'presents'. In 'Blink' victims were thrown back through time to meet 'young' old friends when themselves old and dying, whereas here the Doctor steps back into the station for a moment only to return after Reinette's death. The two times slide uneasily alongside each other, like strata of differing thicknesses in the same rock.

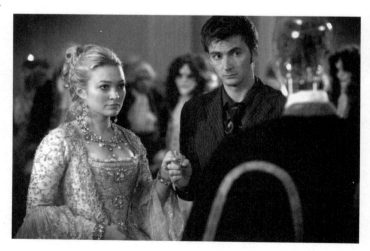

4. *Doctor Who* (2007).

Doctor Who's adventures in the development and evolution of humanity provide a rich example of a television show playing with, if not actually doing, philosophy. Many of the stories, for instance, illustrate the varying organisations of the BwO that Deleuze and Guattari outline, the 'doubles' that the nascent BwO might turn into. The clockwork robots, for example, in reconditioning the spaceship, create a *cancerous* body that relies on rote repetition of form. This is the body that becomes a despotic, totalising body, well represented in *Doctor Who*'s most famous monsters, the Daleks. The backstory given to the Daleks in 'Genesis of the Daleks' (1975), in the middle of the series' 1963–89 first run, has them as the product of a fascist-style government bent on both the eradication of the impure and the hastening of their own evolution. Other adventures in *Doctor Who* illustrate similarly cancerous social bodies, such as the Cybermen, who similarly crave a kind of purity through an absurd renewal of the body. At first this is presented as a willing societal choice in 'The Tenth Planet' (1966), but by the time of the show's revival the Cybermen firmly demonstrate a horrific physical co-option as their primary method of social growth. The BwO is therefore best explored in *Doctor Who* as a mirroring of personal and social, or, rather, through a personal body that has a responsibility to the social. On the other hand, the show often presents a *full* (fulfilled) body, such as when the Doctor sparks revolution by speaking directly to insignificant citizens in 'The Sunmakers' (1978) or by hastening their physical evolution in 'The Mutants' (1972). Finally it is the *empty* or *vitreous* BwO, as a shell rather than space of full potentiality, that is presented in the two-part story 'Human Nature/Family of Blood' (2007). Here 'the family' are formless entities who inhabit the bodies of others, including scarecrows. They pursue the Doctor, who, in setting a trap for them, ironically does so by using a fantastic device to 'decant' his personality into a safe place while his human alter ego, John Smith, battles against the aliens. Once revived, however, and understanding that he will

effectively widow Smith's lover, he takes her hand, and together they fill the moment (as a BwO in itself) with the happy life they would otherwise have had, leading to his own happy, natural death.

At the heart of Deleuze and Guattari's later treatment of the body without organs is a philosophy of an ethical life. The key to this, they suggest, is 'knowing whether we have it in our means to make the selection, to distinguish the BwO from its doubles: empty vitreous bodies, cancerous bodies, totalitarian and fascist.'[7] This relies on the continual testing of ideas and futures, of guesses made as to how humanity might turn out, and the presentation of moral and ethical dilemmas. *Doctor Who*, like all good science fiction, manages this through the principal narration of time travel, in which the past, present and future fill up the body without organs.

Getting lost

Let us assume that in real life we don't have a time-travel machine. If time is a body without organs in a state of full potentiality, then how is it that we create the progression that we find so necessary to understand time, to create an image of it with which we are comfortable? For Deleuze, the answer can be found in the philosophy of Bergson, and in particular his work on memory, and the TV show *Lost* provides a useful illustration.

Lost is a prime-time show made by ABC for US television, syndicated around the world, about a group of survivors from the crash of a passenger airliner on a Pacific island. The first two seasons in particular are interesting, since they deal with the classic 'Robinson Crusoe' scenario. They are about the survivors having to come to terms with the crash at first, then with survival, then with the hope for rescue, and finally with the realisation that rescue is unlikely. In addition, all the appropriate nightmares of desert island life are in play: mysterious monsters and wild beasts, other shipwreck survivors and restless natives (here an unidentified group of white people, who may or may not be the

descendants of shipwrecked convicts). When the existence of a research station is discovered, the season's themes begin to include issues of surveillance, control, spirituality and predestination. In later seasons the existence of 'Others', as well as another island, is developed, new characters are introduced, and a complex battle of wits between new and old inhabitants ensues. In the first two seasons, however, the survivors exist mostly with their fears and their memories. This is where the initial success of the show lay.

For many of the episodes, a particular character is the focus, and events on the island are presented in parallel with scenes from their life beforehand. This often includes key moments in their lives: moments of trauma, moments of happiness and moments of choice. The character Sayid (Naveen Andrews), for instance, is an ex-Republican Guardsman from Iraq, whose involvement on the island with rival Sawyer (Josh Holloway) and later 'other' inhabitant Ben (Michael Emerson) brings back traumatic memories of his days learning to torture suspects, first for the Iraqis and later for the coalition forces after the Iraq War – a story developed over a number of episodes.

As survivors of a plane crash, their memories as emotional baggage therefore substitute for their real lost baggage, and only a few are able to retrieve much of what they travelled with except for these memories. Occasionally, however, such as when Kate (Evangeline Lilly) and Sawyer appropriate each other's belongings, it becomes clear that they often share each other's memories because their lives are all already intertwined. Thus the creators of *Lost* hit on an ideal format to develop dramatic narrative through the development of characters' backgrounds, while drawing out an initially simple desert island concept. Indeed, for many episodes, very little actually happens on the island, while small or otherwise insignificant events open up a rich backstory.

In many ways the show's episodes run along the lines of normal flashbacks, and characters learn from their memories much more than facts or faces, and instead moral, intellectual or

even spiritual lessons. These are lived memories that unfold when needed. Only occasionally do characters seem actually to be daydreaming in the show, yet the memories are deep, clear and take time. Each is essentially a fulsome illustration of Bergson and Deleuze's appreciation of our existence in duration, an existence given substance by memory. Firstly, like Bergson, Deleuze sees duration as the background or presupposition of time. Our actual time of the present, however, Deleuze recognises as much more complex. On the one hand the present is always passing, yet on the other hand it always separates our sense of past and future. In fact, if we tried to divide past from future to find the present moment we could never achieve it, since the division would get smaller and smaller infinitely. This is because time is not made up of instants in progression but is itself indivisible as a single presupposition: duration.

What we call the instant, then, is in fact psychologically felt as we try to make sense of the time that will come and the time we have been through. The instant is a kind of pure subjectivity called *affection*, often misunderstood as perception.[8] Affection divides the past and the future because it also divides matter and intention, cause and effect, as a series of subjectivities, as impurities 'alloyed' to perception. Here, Deleuze is relying on Bergson's interest in our absolutely basic existence as bodies in time. Matter, the material world, creates needs or choices upon which we act. An example of this is hunger as a *need-subjectivity*, which makes a 'hole in the continuity of things'.[9] We miss something, we feel a bit remote or lost, a bit empty, and we realise (*brain-subjectivity*) where this 'hole' is. We're hungry (*affection-subjectivity*). We have a think and, remembering that there is a fridge in the other room (*recollection-subjectivity*), we think to put our book down and go to get something tasty from it (*contraction-subjectivity*). Affection is therefore an impurity, because it is both a feeling and a memory, mixing with our perceptions. In between matter and memory, then, is affection – here

the pang of hunger. For Deleuze, however, the most significant role taken in this series is that of memory, which is always with us, and without which we would not be able to pass from need, through brain and affection, to contraction. We therefore live constantly within the 'cerebral interval', the gap between affection and contraction, and that gap is filled to bursting with memory.[10] For Deleuze, then, the usefulness in Bergson's work is demonstrated in the realisation that not only are we constantly living in memory, but also that memory itself is the past that we carry with us as a living present: memory as virtual coexistence.

What this means for *Lost* is that the series is potentially endless. Each character's memory is inexhaustible since it is brimful of the past, simply waiting to be oriented toward the present. This is because each character, as with us all, is living in a constant passage of affection, is always in a cerebral interval, so that the smallest and most insignificant 'hole in continuity' has the potential to provide an hour of television. Hunger, for instance, arises at first in discussions about the airline food running out, or how to catch fish, but develops into a wider story about social responsibility and guilt through the character of Hurley (Jorge Garcia). An obese, fast-food employee, Hurley is wracked with guilt about an accidental death possibly caused by his weight. In the episode 'Everybody Hates Hugo', he is put in charge of a food locker found in a research station, a situation that causes him to remember his past and the day he won the lottery. This was also a situation of potential change and personal or social responsibility, and the episode plays out his anxieties via his dreams as well as his flashbacks. In a later episode, 'Dave', after Hurley has eventually distributed the food, a ration crate is parachuted onto the island, this time causing him to remember his period in a mental institution as a result of his guilt and consequent overeating. In sum, Hurley's guilt about this accident, his overwhelming worries about social responsibility, tinged also with guilt about survival (he is often the one to conduct the eulogy

over dead comrades), are lived through as memories, bundled with real needs in the present situation.

If we live in memory, how do we go about selecting the correct memories for the present situation? Furthermore, if memory is a virtual coexistence, then from where do we get the impression of going back in time? What makes a flashback seem like a flash *back*? For instance, *Lost* uses very limited on-screen indications of memory, often with the simplest indication that the action is off the island. Otherwise, many episodes start with a character looking directly in the air, although this may or may not be in that character's past. Nonetheless, when watching television shows such as *Lost*, as with our own memories, we immediately get a sense of pastness, even before plotlines become clear. This is because, as Bergson and Deleuze note, we leap into memory, rather than recomposing the past: 'We place ourselves at once in the element of sense, then in a region of this element.'[11] So memory is, in a sense, like getting lost in an unfamiliar forest, as so many of *Lost*'s characters do. At first we sense simple difference – a different place – before getting our bearings as we receive more information. The period of disorientation that many of the characters experience in episodes beginning in flashback is an illustration of this, but this is also reflected in our own disorientation as we try to make sense of the story unfolding as more and more snippets of flashback are revealed. We get lost in their memories, and gradually get our bearings. This is especially the case with the character of Locke (Terry O'Quinn), whose intermittent paraplegia means that his flashbacks are the most disorienting, making his psychological development in the series perhaps the most complex. A similar situation obtains with Korean couple Sun (Daniel Dae Kim) and Jin (Yunjin Kim), whose memories each narrate two very different aspects of the same story, often with the whole of previous episodes given new meaning as each of the troubled lovers' memories are shown to us. While this emphasises above all the personal and unreliable nature of all

memory, in particular it demonstrates how memory is chosen because of its usefulness to the present. When, in flashback, Sun is about to leave her relationship with Jin by leaving him boarding the doomed flight at the airport, it is *her* memories we see when she needs them to inform her present situation on the island. Later it becomes clear that we have not seen all that occurs at the airport – that Jin, a mob enforcer for Sun's father, has been made aware of her affair and her plan to escape. This awareness prompts from him the first of a series of attempts at reconciliation that will continue on the island as they become a stronger couple.

While some of the early episodes might have centred on otherwise minor 'holes in continuity' for the characters, such as hunger, a continued focus on the seemingly insignificant would be dizzyingly boring. As would be expected, many of the flashbacks in *Lost* are increasingly oriented toward graver and graver situations, entailing new moments of choice, new happiness, new trauma, and the interweaving lives of the passengers is revealed in more detail. We have to understand this orientation of the memory toward the present situation as one of usefulness – a literal orientation, in fact. Memories are required to inform the present, and so reveal new ideas, new paths to take. This is the case for drug lord Mr Eko (Adewale Akinnuoye-Agbaje), whose memory quite literally speaks to him via the apparition of his brother Yemi. Because we already live in memory, it is recollection that is directing or guiding perception. When we are troubled we 'appeal to recollection' to inform us.[12] Memory responds in two movements: '[O]ne of translation, by which it moves in its entirety to meet experience, thus contracting more or less…and the other of rotation upon itself, by which it turns toward the situation of the moment, presenting to it that side of itself which may prove to be the most useful.'[13] Memory therefore appears to act in the manner of an old jukebox, or in the same way that we might choose old records on a gramophone. We make a selection (appeal to the past), the machine picks the record, turns it over so the correct side

faces us, and plays us what we want to hear. Indeed, the research station that the survivors find in season two of *Lost* has an old record player, whose accompanying collection of records from the 1960s and 1970s suggests that the station is long abandoned. Just like Bergson and Deleuze's jukebox memory, however, this record player is a red herring: the station has been manned throughout the intervening period, with new personnel arriving within the last few years. We need to remember the spatial description of memory. We get lost (appeal), but begin to understand our surroundings (translation, contraction) and choose which way to explore (rotation/orientation). It is we who orient ourselves toward memory, within memory, not the other way around.

The characters' memories therefore mark out their time on the island, and the only clock available is a countdown mechanism set at the odd interval of 108 minutes, which requires resetting by entering a code into a computer in the research station. For Locke, Desmond (Henry Ian Cusick) and Mr Eko, the choice to press the button is one that arises from their memories, which inform their decisions. Perhaps the most brutal sense of memory's usefulness is in the case of Sayid. His memory of learning to commit acts of torture do not so much create new trauma for him as remind him how to do it – taking him through the same choices, the same personal pains, the same urgency that he faces in the present: to extract information through violence in order to save other lives. It is from memory that he perceives the opportunity and necessity to carry it out, however. The example of Sun and Jin similarly demonstrates that the usefulness of memory is based on present action, rather than objective truth, and, as viewers, we are asked to assume that their memories are not complicated by illness, for example, as Hurley's are. Nevertheless, the show's relatively *flat* depiction of flashback leads us to assume a presupposed subjective truth, which is affect. In watching *Lost* it is not necessarily important to know that we are seeing the whole past, but simply that we understand why these characters are searching for these memories in the forest.

Conclusion: Reframing Deleuze

Ultimately, Deleuze's is a *productive* philosophy, one that should engender creative thought. For that reason, Deleuze has become popular with artists especially, and with creative individuals more generally. As authors we think, for instance, that Deleuze is indispensable to the creative individual. This does not mean that every creative act can be philosophical, however, or even that we will know it to be able to create it. If it did, then we would end up like Rancière's aimless artists, endlessly pushing the materials around, endlessly making only material decisions in the vain hope that one day we might break the cliché. We might imagine that we can create concepts, but in fact we would have given up aesthetic thought. If we try to endlessly create, endlessly repeat creation, then we will not be the engineers of situations we need to be in order to really create the conditions from which a new concept will arise. How, then, can Deleuze's philosophy be truly useful?

Deleuze's is a philosophy of the society yet to come, and it starts with a philosophy of life itself. This is the powerful life that exists under the skin of things, the very principle of substance. Throughout Deleuze's philosophy there is a strange insistence, a thunderous heartbeat whose throbs are felt in the philosophy of becoming, of duration, and the instant, and in the inevitability of deterritorialisation and reterritorialisation. This is the sound made by Deleuze's thinking on immanence – thinking it for us, grasping it as a fact so that we might glimpse it as he does. Deleuze's philosophy is marked by the fact that life is happening, life simply *is*, and this should stiffen our resolve to create a better

formation. It requires being watchful and careful in a creative sort of way.

We started here by looking at the rhizome as a principle of organisation as well as a principle of action. Through Deleuze's philosophy we saw how the patterns of society emerge as arborescent forms based on simple, linear hierarchies – transformations of a principle of difference into structure. We also considered the powers of deterritorialisation that exist in cultural activity and formation, resistant powers that have the ability to disassemble hierarchies. We were also forced to consider the inevitability of reterritorialisation, however, the powers that molar formations – capitalist patriarchy, for instance – have in recuperating or co-opting those powers of deterritorialisation. It is all too easy for resistance and opposition to become part of the mainstream. We looked at this first in video games and the logic of achievement that trains the gamer for capitalism, and then in the structures of the Internet, which foster a sense of resistance that can so easily become part of capitalist culture or insidious nihilism.

The powers of deterritorialisation still exist, however, and so, as a political philosophy, Deleuze and Guattari's rhizomatic thinking requires effort and watchfulness, and most of all an awareness of the continual change that supplies the impetus for growth for the rhizome or the tree. This growth is the trace of insistent change, the constant coming-into-being, or becoming. We looked at this from the point of view of the artwork, illustrating, for instance, the creation of canonical 'molar' artworks and artists from even the most exciting of potential resistance. We also looked at the ways in which filmmakers, for example, disassemble from within the majoritarian language with which they work, by making cinema stutter and stammer. In the end we demonstrated how these practices require the engineering of situations, the coordination of the material (film, concrete, found objects) and the contingent (language, meaning, social interaction), in order to create artworks that last the test of time. These practices make use

of becoming itself, the insistent change that offers the potential for political change, for example, in playing film language in a minor key, subtly affecting and reforming it from within. The key to creating lasting artworks and films is to realise that sensational effect never actually lasts, and never actually speaks to new situations, and instead to realise the need to address the very change in situations themselves.

This led us on to deal with the thundering insistence that gives change itself substance, the impetus of life. Deleuze identified this as immanence, about which we can know but never think, never give a representation. We can experience it only through the open-ended duration in which we exist. This immanence is the substance of duration itself, and duration is thus the trace in thought left by the knowledge of immanence. We found that we use time to make sense of immanence, to give it some sort of shape in our lives. We found this when looking at television's depiction of time, whether experienced on a grand scale as history or sensed as the pastness of memory and reflection. Time-travel narratives dismantle the boundaries of past and present to reveal the smooth immensity of duration. Thriller narratives, on the other hand, reveal how our lives are experienced through memory, which orients us to the pressing matters at hand. We also encountered this notion of 'making sense of time' in Deleuze's brilliant analysis of cinema and its two images of time. One, the movement-image, is based on the movement of objects in space to create a narration system of cause and effect. The other, the time-image, offers us the virtual whole of time, experienced through the collapse of past and present, or through the unfolding of a moment to reveal multiple paths and labyrinthine possibilities. We found, however, that the time-image had developed from industrial and cultural situations in opposition to Hollywood's mainstream filmmaking (and its reliance upon the movement-image), and was adopted by mainstream filmmakers to present within narratives now 'classic' ideas of subjective or aberrant time in cinema's hybrid-images.

Once again, Deleuze's philosophy requires a watchful eye toward the powers of reterritorialisation.

Overall, we have tried to demonstrate how visual culture, in particular media forms such as video games, the Internet, cinema, television and art, frame our world for us. Media forms help us make sense of some of our most basic intuitions – that we are in time, that we are in society, that we form an identity, and that we change and are a part of change. The greatest value in Deleuze's philosophy is that it provides us with analytical and conceptual tools to see and understand this framing of our world through visual culture.

So, finally, how can we go about putting Deleuze's philosophy to new work? We have attempted in this guide to illustrate some of Deleuze's key ideas in a manner that will allow them to continue to be useful for the new thinkers who will be brought into being by the new social, political and artistic situations that occur. We have written this to appeal to the new thinker who refuses to just play a video game, who refuses to just surf the net, and who refuses to sit back and simply watch. We have written this also, however, to appeal to the thinker who is not satisfied with mere resistance and opposition to what he or she sees as social inequality or inequity, since mere opposition can only restate the principles of difference themselves. We have written this to appeal to the artist who does not want simply to make philosophical art, but who wants to engineer the conditions of the situation and the material so that the artwork will create resonances with philosophy and be truly monumental.

Deleuze's is a productive philosophy, and to be truly creative the new thinker needs to adopt some of the tactics that Deleuze himself adopted: go to the sources, keep asking questions, look for new concepts and ideas in the material. The new thinker must look for new formations and new organisations, within which to play in a minor key. Deleuze's philosophy is kept current by his interaction with philosophers from key points in intellectual

history, and this accounts for his crucial position in the intersection of visual culture with a new and emergent society of the image. His work promises fruitful new collaborations and relationships with contemporary philosophers and other creative individuals. His ideas are there to be developed by other thinkers who wish to engage them with similar precision and integrity, as he himself engaged others with both verve and diligence. Deleuze's work is testament to philosophy as a conversation in progress, a discussion in which ideas are continually reframed, retested and questioned anew. This means that we feel it is important to keep returning to Deleuze, to develop his philosophy and to continue to encounter it anew. This is at the core of his relationship with Bergson, for instance, or in his working collaboration with Guattari.

Working with Deleuze is an experience that is never the same twice, because Deleuze's philosophy informs for situations in continual change, and in fact helps express and understand that change in itself. As authors, for instance, we have so much more to do, and the task that we have given ourselves (in our own projects as well as ones such as this) is an ongoing one. One aim is to look at new configurations of Deleuze and other thinkers, past and future. Another is to look at new creative forms and other creative media, considering the ways in which they give rise to new concepts, or how they reconfigure existing ones in new situations. To do this we need to go to the sources, reading those we haven't read before, trying new ones that appear as exciting new thinkers encounter Deleuze for the first time. We aim, above all, to make full use of Deleuze's productive and creative philosophy. Care to join us?

Notes

Foreword

1 Ian Buchanan, Introduction to *A Deleuzian Century?*, special issue, *South Atlantic Quarterly*, vol. 96, no. 3 (1997), 389.
2 Gilles Deleuze and Félix Guattari, *What Is Philosophy?*, trans. Graham Burchell and Hugh Tomlinson (New York, NY: Columbia University Press, 1994).
3 John Rajchman, *The Deleuze Connections* (Cambridge, MA: MIT Press, 2000), 115.
4 Ibid.

Part One: Introduction

1 Gilles Deleuze and Félix Guattari, *A Thousand Plateaus: Capitalism and schizophrenia*, trans. Brian Massumi, 3rd edn (London: Athlone, 1996).
2 Ibid., 21.
3 Ibid., 6–7.
4 Ibid., 9.
5 Ibid., 10.
6 Ibid.
7 Gilles Deleuze and Félix Guattari, *Anti-Oedipus: Capitalism and schizophrenia* (Minneapolis, MN: University of Minnesota Press, 1983), 51.
8 Ibid., 112.
9 For a fuller discussion of the influence of May 1968 on Deleuze's thought, see D. N. Rodowick, *Reading the Figural, or Philosophy after the New Media* (Durham, NC: Duke University Press, 2001), 170–202. For a more general discussion of this time period on Deleuze and Guattari's thought, see Michel Foucault's introduction to *Anti-Oedipus*, xi–xiv.

Chapter 1

1 Much of this is a summary of information contained in Steven Poole, *Trigger Happy* (New York, NY: Arcade, 2000); Steven L. Kent, *The Ultimate History of Video Games* (New York, NY: Three Rivers Press, 2001); Mark

J.P. Wolf and Bernard Perron (eds), *The Video Game Theory Reader* (London: Routledge, 2003); James Newman, *Videogames* (London: Routledge, 2004); and John Kirriemuir, 'A History of Digital Games', in *Understanding Digital Games*, eds Jason Rutter and Jo Bryce (London: Sage, 2006), 21–35.

2 Kirriemuir, 'A History of Digital Games', 23.

3 Poole, *Trigger Happy*, 18–20.

4 Andreas Huyssen, *After the Great Divide: Modernism, mass culture and postmodernism* (London: Macmillan, 1986), 44–62.

5 www.gamestudies.org.

6 Gilles Deleuze, *Cinema 2: The time-image* (1985), trans. Hugh Tomlinson and Robert Galeta, 2nd edn (London: Athlone, 1994), 131; Jorge Louis Borges, 'The Garden of Forking Paths', in *Labyrinths* (London: Penguin, 1962), 44–54.

7 Newman, *Videogames*, 108–9.

8 Barry Atkins, *More than a Game* (Manchester: Manchester University Press, 2003), 59–60.

9 Gonzalo Frasca, 'Simulation versus Narrative', in Wolf and Perron (eds), *The Video Game Theory Reader*, 221–35.

10 There has been some very justifiable criticism of the idea that gamers actually create a 'community' as such, because communities usually have 'ethical dimensions' rather than simply being a group of people who communicate virtually, as is the case in gaming communities. For a fuller discussion of this debate, see Martin Hand and Karenza Moore, 'Gaming, Identity and Digital Games', in Rutter and Bryce (eds), *Understanding Digital Games*, 166–82, 173.

11 Miroslaw Filiciak, 'Hyperidentities', in Wolf and Perron (eds), *The Video Game Theory Reader*, 87–102, 97.

12 For a more in-depth examination of LAN parties, see Hand and Moore, 'Gaming, Identity and Digital Games', 168–69.

13 Filiciak, 'Hyperidentities', 90.

14 Kirriemuir, 'A History of Digital Games', 33.

15 Jo Bryce and Jason Rutter, 'Spectacle of the Deathmatch', in *ScreenPlay: Cinema, videogames, interfaces*, eds Geoff King and Tanya Krzywinska (London: Wallflower, 2002), 66–80, 69.

16 Bryce and Rutter, 'Spectacle of the Deathmatch', 75.

17 For a fuller analysis of this argument, see Sue Morris, 'First-person Shooters – A Game Apparatus', in King and Krzywinska (eds), *ScreenPlay: Cinema, videogames, interfaces*, 81–97.

18 Morris, 'First-person Shooters – A Game Apparatus', 94.

19 Jo Bryce and Jason Rutter, 'Digital Games and the Violence Debate', in Rutter and Bryce (eds), *Understanding Digital Games*, 205–22, 207–11.

20 Poole, *Trigger Happy*, 177.

21 Ibid., 235.

22 Ibid., 208–9.

23 Ibid., 17.

24 Ibid., 180–1.

25 Bryce and Rutter, 'Digital Games and the Violence Debate', 208.

26 Derek A. Burrill, 'Oh, Grow Up 007', in King and Krzywinska (eds), *ScreenPlay: Cinema, videogames, interfaces*, 181–93, 182.

27 Mia Consalvo, 'Hot Dates and Fairy-tale Romances', in Wolf and Perron (eds), *The Video Game Theory Reader*, 171–94, 188.

28 Poole, *Trigger Happy*, 208–11.

29 Gonzalo Frasca, 'Sim Sin City: Some thoughts about *Grand Theft Auto 3*', *Game Studies*, vol. 3, no. 2 (2003): www.gamestudies.org/0302/frasca (accessed 26/6/2006).

Chapter 2

1 Deleuze and Guattari, *A Thousand Plateaus*, 270.

2 Deleuze and Guattari, *What Is Philosophy?*, 59.

3 Ibid.

4 Gisle Hannemyr, 'The Internet as Hyperbole: A critical examination of adoption rates', *The Information Society*, vol. 19 (2003), 114–15.

5 Arturo Escobar, 'Welcome to Cyberia: Notes on the anthropology of cyberculture', *Current Anthropology*, vol. 35, no. 3 (1994), 214.

6 Tim Jordan, 'Language and Libertarianism: The politics of cyberculture and the culture of cyberpolitics', *Sociological Review*, vol. 49, no. 1 (2001), 9.

7 Hans Magnus Enzensberger, 'Constituents of a Theory of the Media (1970)', in *Raids and Reconstructions* (London: Pluto Press, 1976), 20–53, 22.

8 Ibid., 34–5.

9 Louis Althusser, 'Ideology and Ideological State Apparatuses (Notes towards an Investigation) (1969)', in *Lenin and Philosophy*, trans. Ben Brewster (London: New Left Books, 1971), 127–88, 146.

10 Enzensberger, 'Constituents of a Theory of the Media', 32.

11 Charlie Brooker, *TV Go Home*, 14 July 2000, www.tvgohome.com/1407-2000.html (accessed 20/10/2006).

12 Enzensberger, 'Constituents of a Theory of the Media', 37.

13 'http://www.whoislupo.com/ – almost an object lesson in how not to do this', Need to Know, 16 November 2001, www.ntk.net/2001/11/16 (accessed 20/10/2006).

14 McKenzie Wark, 'Information Wants to be Free (But is Everywhere in Chains)', *Cultural Studies*, vol. 20, nos 2–3 (2006), 165–83, 172.

15 Michael Hardt and Antonio Negri, *Empire* (Cambridge, MA: Harvard University Press, 2001), 326–7.

16 Eileen R. Meehan, '"Holy Commodity Fetish, Batman!": The political economy of a commercial intertext', in Roberta Pearson and William Uricchio, *The Many Lives of the Batman* (eds), (London: Routledge/British Film Institute, 1991), 47–65, 54.

Part Two: Introduction

1 Gilles Deleuze, *The Fold: Leibniz and the baroque*, trans. Tom Conley (London: Athlone, 1993), 19.

2 Deleuze and Guattari, *A Thousand Plateaus*, 232–309.

3 Ibid., 236.

4 Rosi Braidotti, *Patterns of Dissonance: A study of women in contemporary philosophy*, trans. Elizabeth Guild (London: Polity Press, 1991), 121.

5 Deleuze and Guattari, *A Thousand Plateaus*, 241.

6 Ibid., 253.

7 Ibid., 257.

Chapter 3

1 Gilles Deleuze and Félix Guattari, *Kafka: Toward a minor literature* (Minneapolis, MN: University of Minnesota Press, 1986), 16.

2 Ibid., 24–5.

3 Deleuze and Guattari, *A Thousand Plateaus*, 104.

4 Ibid.

5 Ibid.

6 Deleuze, *Cinema 2*, 218.

7 Ibid., 215–24.

8 Ibid., 217.

9 Ibid., 215–16.

10 Deleuze and Guattari, *Kafka*, 17.

11 D. N. Rodowick, *Gilles Deleuze's Time Machine* (Durham, NC: Duke University Press, 1997), 153.

12 Ibid., 162–9.

13 Mette Hjort, *Small Nation: Global cinema* (Minneapolis, MN: University of Minnesota Press, 2005); David Martin-Jones, 'Orphans, a Work of Minor Cinema from Post-devolutionary Scotland', *Journal of British Cinema and Television*, vol. 1, no. 2 (2004), 226–41; Bill Marshall, *Quebec National Cinema* (Montreal: McGill-Queen's University Press, 2001); Hamid Naficy, *An Accented Cinema: Exilic and diasporic filmmaking* (Princeton, NJ: Princeton University Press, 2001); Laura U. Marks, *The Skin of the Film: Intercultural cinema, embodiment and*

the senses (Durham, NC: Duke University Press, 2000); Meaghan Morris, *Too Soon Too Late: History in popular culture* (Bloomington: Indiana University Press, 1998); Alison Butler, *Women's Cinema: The contested screen* (London: Wallflower, 2002); Belen Vidal, 'Playing in a Minor Key', in *Books in Motion: Adaptation, intertextuality, authorship*, ed. Mireia Aragay (Amsterdam: Rodolphi, 2005).

14 Geoff King, *American Independent Cinema* (London: I.B. Tauris, 2005), 222–49; Glyn Davis, 'Camp and Queer and the New Queer Director: Case study – Gregg Araki', in *New Queer Cinema: A Critical Reader*, ed. Michele Aaron (Edinburgh: Edinburgh University Press, 2004), 53–67.

15 King, *American Independent Cinema*, 83, 235–6; Katie Mills, 'Revitalizing the Road Movie', in *The Road Movie Book*, ed. Steven Cohan and Ina Rae Hark (London: Routledge, 1997), 308–13; James M. Moran, 'Gregg Araki: Guerrilla film-maker for a queer generation', *Film Quarterly*, vol. 5, no. 1 (1996), 18–26, 19–20; Kylo-Patrick R. Hart, '"Auteur/Bricoleur/Provocateur": Gregg Araki and postpunk style in the Doom Generation', *Journal of Film and Video*, vol. 55, no. 1 (2003) 30–8, 33; and Chris Chang, 'Absorbing Alternative', *Film Comment*, vol. 3, no. 5. 47–53, 53.

16 For a full discussion of this sequence, see Kaja Silverman, *Male Subjectivities at the Margins* (London: Routledge, 1992), 90–106.

17 S. F. Said, 'Close Encounters', *Sight and Sound*, vol. 15, no. 6 (2005), 32.

Chapter 4

1 Deleuze and Guattari, *What Is Philosophy?*, 172.

2 Gregg Lambert, *The Non-philosophy of Gilles Deleuze* (London: Continuum, 2002), 152.

3 Deleuze and Guattari, *A Thousand Plateaus*, 291.

4 Kobena Mercer, 'Imaging the Black Man's Sex', in *Photography/Politics Two*, ed. Patricia Holland, Simon Watney and Jo Spence (London: Comedia, 1986), 61.

5 Richard Meyer, 'The Jesse Helms Theory of Art', *October*, no. 104 (2003), 131–48, Steven C. Dubin, *Arresting Images: Impolitic art and uncivil action* (London: Routledge, 1992).

6 Meyer, 'The Jesse Helms Theory of Art', 142.

7 Dubin, *Arresting Images*, 187

8 Ibid., 188.

9 Mercer, 'Imaging the Black Man's Sex', 63.

10 Ibid.

11 Deleuze and Guattari, *A Thousand Plateaus*, 291.

12 Ibid.

13 Juha-Pekka Vanhatalo, 'Coco Fusco – Life under Surveillance', *Kiasma Magazine*, no. 12 (2001), www.kiasma.fi/index.php?id=172&FL=1&L=1 (accessed 23/01/2007).

14 Deleuze and Guattari, *What Is Philosophy?*, 191.

15 Deleuze and Guattari, *A Thousand Plateaus*, 300.

16 Deleuze and Guattari, *What Is Philosophy?*, 182.

17 Ibid., 169.

18 Ibid., 193.

19 Nicholas Bourriaud, *Relational Aesthetics* (Paris: Les presses du reel, 2002), 14.

20 Ibid., 19.

21 Ibid., 20.

22 Ibid., 41.

23 Jacques Rancière, *The Politics of Aesthetics: The distribution of the sensible*, trans. Gabriel Rockhill (London: Continuum, 2004), 13.

24 Deleuze and Guattari, *What Is Philosophy?*, 176.

Part Three: Introduction

1 See Henri Bergson, *Time and Free Will: An essay on the immediate data of consciousness* (1889), trans. F. L. Pogson (Mineola, NY: Dover, 2001); *Matter and Memory* (1896), trans. Nancy Margaret Paul and W. Scott Palmer, 5th edn (New York, NY: Zone, 1996); *Creative Evolution* (1907), trans. Arthur Mitchell (New York, NY: Macmillan, 1998); and *Duration and Simultaneity* (1921), trans. Robin Durie and Mark Lewis (Manchester: Clinamen Press, 1999).

2 Deleuze, *Cinema 2*, 274.

3 Bergson, *Matter and Memory*, 162.

4 Bergson, *Creative Evolution*, 2.

5 Ibid, 4–5.

Chapter 5

1 André Bazin, *What is Cinema?*, vol. II, trans. Hugh Gray, 2nd edn (Berkeley, CA: University of California Press, 1971), 76–7; David Bordwell and Kristin Thompson, *Film History: An introduction*, 2nd edn (Boston, MA: McGraw-Hill, 2003), 364.

2 Deleuze, *Cinema 2*, 1.

3 Deleuze, *Cinema 2*, 131; Borges, 'The Garden of Forking Paths', 44–54.

4 Deleuze, *Cinema 2*, 101; Rodowick, *Gilles Deleuze's Time Machine*, 100–8.

5 Deleuze, *Cinema 2*, 103.

6 Anna Powell, *Deleuze and Horror Film* (Edinburgh: Edinburgh University Press, 2005).

7 Deleuze, *Cinema 2*, xi.
8 Patricia Pisters, *The Matrix of Visual Culture: Working with Deleuze in film theory* (Stanford, CA: Stanford University Press, 2003) 43–4.
9 Ibid., 3–4. For a detailed explanation of the crystal of time see, Deleuze, *Cinema 2*, 68–97.
10 Pisters, *The Matrix of Visual Culture*, 44.
11 For a greater discussion of *Spellbound* and several other famous dream sequences, see Deleuze, *Cinema 2*, 57–8.
12 Deleuze, *Cinema 2*, 92.

Chapter 6

1 Michael Hardt, *Gilles Deleuze: An apprenticeship in philosophy* (Minneapolis, University of Minnesota Press, 1993).
2 A later part of the conversation repeats: Sally: 'Let me get my head round this: you're reading aloud from a transcript of a conversation you're still having?' The Doctor: 'Uh…wibbly-wobbly…timey-wimey…'
3 Deleuze and Guattari, *Anti-Oedipus*, 10.
4 Deleuze and Guattari, *A Thousand Plateaus*, 159.
5 Ibid.
6 Hardt and Negri, *Empire*, 327.
7 Deleuze and Guattari, *A Thousand Plateaus*, 165.
8 Bergson, *Matter and Memory*, 58.
9 Gilles Deleuze, *Bergsonism* (1966), trans. Hugh Tomlinson and Barbara Habberjam (New York, NY: Zone, 1997), 52.
10 Ibid., 53.
11 Ibid., 57.
12 Ibid., 63.
13 Bergson, *Matter and Memory*, 168–9.

Select bibliography

When we have made reference to works by Deleuze we have used the imprint we have to hand. For this bibliography we have put Deleuze's major work in chronological order, with each book's year indicated.

By Gilles Deleuze

Empiricism and Subjectivity: An essay on Hume's theory of human nature, 1953, trans. Constantin V. Boundas New York, NY: Columbia University Press, 1991.

Nietzsche and Philosophy, 1962, trans. Hugh Tomlinson, London: Athlone, 1983.

Kant's Critical Philosophy: The doctrine of the faculties, 1963, trans. Hugh Tomlinson and Barbara Habberjam, London: Athlone, 1995.

Proust and Signs, 1964, trans. Richard Howard, New York, NY: Braziller, 1972.

Bergsonism, 1966, trans. Hugh Tomlinson and Barbara Habberjam, New York, NY: Zone, 1997.

Difference and Repetition, 1968, trans. Paul Patton, 2nd edn, London: Athlone, 1997.

The Logic of Sense, 1969, trans. Mark Lester and Charles Stivale, London: Athlone, 1990.

Expression in Philosophy: Spinoza, 1970, trans. Martin Joughin, 2nd edn, New York, NY: Zone, 1992.

Francis Bacon: The logic of sensation, 1981, trans. Daniel W. Smith, London: Continuum, 2005.

Cinema 1: The movement-image, 1983, trans. Hugh Tomlinson and Barbara Habberjam, 2nd edn, London: Athlone, 1997.

Cinema 2: The time-image, 1985, trans. Hugh Tomlinson and Robert Galeta, 2nd edn, London: Athlone, 1994.

Foucault, 1986, trans. Sean Hand, London: Athlone, 1988.

The Fold: Leibniz and the baroque, 1988, trans. Tom Conley, London: Athlone, 1993.

Essays Critical and Clinical, 1993, trans. Daniel W. Smith and Michael A. Greco, Minneapolis, MN: University of Minnesota Press, 1997.

See also

Dialogues (with Claire Parnet), 1977, trans. Hugh Tomlinson and Barbara Habberjam, London: Athlone, 1987.

The Deleuze Reader, 1993, ed. Constantin V. Boundas, New York, NY: Columbia University Press, 1993.

Negotiations, 1972–90, 1995, trans. Martin Joughin, New York, NY: Columbia University Press, 1995.

Pure Immanence: Essays on a life, ed. John Rajchman, trans. Anne Boyman, New York, NY: Zone, 2001.

By Deleuze and Guattari

Anti-Oedipus: Capitalism and schizophrenia, 1972, trans. Robert Hurley, Mark Seem, and Helen R. Lane, London: Athlone, 1984.

Kafka: Toward a minor literature, 1975, trans. Dana Polan, Minneapolis, MN: University of Minnesota Press, 1986.

A Thousand Plateaus: Capitalism and schizophrenia, 1980, trans. Brian Massumi, 3rd edn, London: Athlone, 1996.

Nomadology: The war machine, 1986, trans. Brian Massumi, New York, NY: Semiotext(E), 1986.

What Is Philosophy?, 1994, trans. Graham Burchell and Hugh Tomlinson, New York, NY: Columbia University Press, 1994.

Useful commentaries

Alliez, Eric, *The Signature of the World, or, What Is Deleuze and Guattari's Philosophy?*, trans. Eliot Ross Albert and Alberto Toscano, London: Continuum, 2004.

Ansell Pearson, Keith, *Germinal Life: The difference and repetition of Deleuze*, London: Routledge, 1999.

Badiou, Alain, *Deleuze: The clamor of being*, trans. Louise Burchill, Minneapolis, MN: University of Minnesota Press, 2000.

Boundas, Constantin V., ed. *Deleuze and Philosophy*, Edinburgh: Edinburgh University Press, 2006.

Boundas, Constantin V. and Dorothea Olkowski, eds, *Gilles Deleuze and the Theatre of Philosophy*, London: Routledge, 1993.

Buchanan, Ian, *Deleuzism: A metacommentary*, Edinburgh: Edinburgh University Press, 2000.

 ed., *A Deleuzian Century?*, Durham, NC: Duke University Press, 1999.

Buchanan, Ian and Adrian Parr, *Deleuze and the Contemporary World*, Edinburgh: Edinburgh University Press, 2006.

Colebrook, Claire, *Gilles Deleuze*, London: Routledge, 2002.

Hallward, Peter, *Out of this World: Deleuze and the philosophy of creation*, London: Verso, 2006.

Hardt, Michael, *Gilles Deleuze: An apprenticeship in philosophy*, London: Routledge, 1993.

Grosz, Elizabeth, ed., *Becomings: Explorations in time, memory, and futures*, Ithaca, NY: Cornell University Press, 1999.

Rajchman, John, *The Deleuze Connections*, Cambridge, MA: MIT Press, 2000.

Stivale, Charles, *The Two-fold Thought of Deleuze and Guattari: Intersections and animations*, London: Guildford Press, 1999.

Žižek, Slavoj, *Organs without Bodies: Deleuze and consequences*, London: Routledge, 2003.

Deleuze in the arts

Bogue, Ronald, *Deleuze on Cinema*, London: Routledge, 2003.

 , *Deleuze on Literature*, London: Routledge, 2003.

 , *Deleuze on Music, Painting, and the Arts*, London: Routledge, 2003.

Bryden, Mary, *Gilles Deleuze: Travels in literature*, Basingstoke: Palgrave Macmillan, 2007.

Buchanan, Ian and Marcel Swiboda, *Deleuze and Music*, Edinburgh: Edinburgh University Press, 2004.

Buchanan, Ian and Gregg Lambert, *Deleuze and Space*, Edinburgh: Edinburgh University Press, 2005.

Flaxman, Gregory, *The Brain Is the Screen: Deleuze and the philosophy of cinema*, Minneapolis, MN: University of Minnesota, 2000.

Kennedy, Barbara, *Deleuze and Cinema: The aesthetics of sensation*, Edinburgh: Edinburgh University Press, 2002.

Lambert, Gregg, *The Non-philosophy of Gilles Deleuze*, London: Continuum, 2002.

Marks, Laura U., *The Skin of the Film: Intercultural cinema, embodiment and the senses*, Durham, NC: Duke University Press, 2000.

Martin-Jones, David, *Deleuze, Cinema and National Identity*, Edinburgh: Edinburgh University Press, 2006.

Massumi, Brian, ed., *A Shock to Thought: Expression after Deleuze and Guattari*, London: Routledge, 2002.

Olkowski, Dorothea, *Gilles Deleuze and the Ruin of Representation*, Berkeley, CA: University of California Press, 1999.

O'Sullivan, Simon, *Art Encounters Deleuze and Guattari*, Basingstoke: Palgrave Macmillan, 2006.

Pisters, Patricia, *The Matrix of Visual Culture: Working with Deleuze in Film Theory*, Stanford, CA: Stanford University Press, 2003.

_____, ed., *Micropolitics of Media Culture: Reading the rhizomes of Deleuze and Guattari*, Amsterdam: Amsterdam University Press, 2001.

Powell, Anna, *Deleuze and Horror Film*, Edinburgh: Edinburgh University Press, 2005.

Rodowick, D. N., *Gilles Deleuze's Time Machine*, Durham, NC: Duke University Press, 1997.

_____, ed., *The Afterimage of Gilles Deleuze's Film Philosophy*, Minneapolis, MN: University of Minnesota Press, 2008.

Sutton, Damian, *Photography, Cinema, Memory: The Crystal Image of Time*, Minneapolis, MN: University of Minnesota Press, 2009.

Zepke, Stephen, *Art as Abstract Machine: Ontology and aesthetics in Deleuze and Guattari*, London: Routledge, 2006.

Online resources

A/V - Actual/Virtual, Deleuze journal: www.eri.mmu.ac.uk/deleuze/

Deleuze at Greenwich, academic blog: http://deleuzeatgreenwich. blogspot.com/

Film-philosophy.com, International Salon-Journal: www.film-philosophy .com/

Offscreen, film criticism with Deleuze page: www.offscreen.com/biblio/ lib/cat/deleuze/

Rhizome, artbase and resource: www.rhizome.org/

Rhizomes, online journal: www.rhizomes.net/

Spoon collective, Deleuze–Guattari List: www3.iath.virginia.edu/spoons/d-g_html/index.html

Stivale, Charles, *Deleuze and Guattari Web Resources*: www.langlab.wayne. edu/CStivale/D-G/

WebDeleuze – French online resource (in French): www.webdeleuze.com/ php/index.html

Glossary

Throughout his career Deleuze developed a number of key ideas and concepts, many of which are discussed in *Deleuze Reframed*. This glossary provides simple definitions of these terms as they relate to Deleuze's work and our discussion, and evidence of how we have worked with Deleuzian concepts. Some of the ideas took Deleuze many years to develop, and many of the terms continue to be resolved and understood anew by scholars of philosophy and visual culture. These definitions, then, represent our present understanding of these complex terms.

affection – A pure subjectivity as the experience of *feeling* in the instant. It is 'alloyed' to other subjectivities – need, brain, recollection and contraction – as we understand what we feel and act upon it. Since these feelings overlap, we live in affection and create a gap, or *cerebral interval*, when we need to make sense of it.

affects – The pure response to an artwork that is articulated through the employment of language and shared cultural meaning. Together with percepts they constitute *blocs of sensation*.

becoming – The ongoing process whereby the world is always coming into being, which we see in relation and proportionality. In terms of identity, becoming explains how identity is formed through experience and the reflexive understanding of opposition, alterity and difference.

becoming-animal – A process of identity whereby the individual is returned, or returns to, the state of animal in order to achieve further self-awareness. that one is reduced to living like an animal in order to survive.

becoming-imperceptible – The absolute elimination of identity as a goal of self-awareness and resistance to processes and hierarchies of domination.

becoming-minoritarian – The principle of becoming experienced through collective resistance to a dominating majority, pursued by employing the language and culture of the majority. Minor cinemas, for example, explore emergent identities (e.g. cultures affected by post-colonial nationalism) or identities problematised by society (e.g. queer cinema) through the use and subversion of mainstream cinematic storytelling.

becoming-woman – The reflexive experience of femininity as a signifier of difference, in relation to man as the *molar* identity against which identity itself is measured. Since it is an experience of identity, rather than an essence, it can be felt by anyone – male or female – as an awakening to social structures based on difference.

Body without Organs (BwO) – Pure substance as it exists before organisation and which allows passage – of ideas, or identities, of time – through its completely smooth structure. The BwO is experienced when organisation breaks down or is revealed to be arbitrary or culturally determined. The BwO is organised and filled by the desire in order to create structure, but can also, as a smooth substance, be a tool of transferability (e.g. capital). The BwO therefore has multiple potential destinations: empty, full or cancerous.

deterritorialisation – The breaking up of order, boundaries and form to produce movement and growth, especially where this involves the survival or the creation of new life (i.e. in nature) or the disturbance of arbitrary or social rules employed in repression.

duration – The pure change of the world, which we organise into chronology as the passing of time. Duration is experienced as an irreducible progress of varying speeds and can unfold to accommodate the most intricate of thoughts and memories.

haecceity – The intersection of bodily materiality and social circumstance; the conditions of our identity.

immanence – The absolute background of life expressed only in the intersection of form, subject, organ and function. This intersection is the *plane of immanence*, which is given shape in objects and their organisation.

memory – The past experienced in the present, and called up or appealed to by present situations. We appeal to memory in order to understand the present, and explore it in order to provide solutions to current problems, ideas and desires.

movement-image – The image of time developed in cinema as a chronology spatialised through editing and montage. For Deleuze, the movement-image is the adoption of the technology of cinema as a principle of narration – frames create shots create montage – which is explored and adopted by Hollywood and other mainstream cinemas. The movement-image both relies upon and enforces the chronological image of time and the progression of cause and effect in culture.

objectile – An identity that exists in time, rather than in space, and which is fixed for a while from becoming the ongoing change of becoming.

percepts – Pure sensations in art that are articulated by the manipulation of materials into language and expression. Together with affects they constitute *blocs of sensation*.

psychoanalysis – The exploration of identity through its development in childhood as a unitary persona in which the unconscious is repressed. For Deleuze and Guattari, psychoanalysis is a tool of territorialisation or reterritorialisation, as much forming the child's identity according to society's norms as deducing when the child's development departs from it and when the unconscious re-emerges through illness, malady or trauma.

reterritorialisation – The re-establishment of order, boundaries and forms to produce stable embodiments or static identities. This might also include the incorporation of radical ideas or practices into dominant social formations.

rhizome – A plant stem that grows horizontally, such as a tuber. The term is also used by Deleuze and Guattari to refer to rootless plants that spread horizontally rather than setting in deeply – such as couch grass. Something that exhibits in shape or activity the attributes of horizontality or lateral growth, as in a rhizome, might be called **rhizomatic**, as opposed to arborescent or tree-like. Something that exhibits in its information the same attributes, in order to produce a rhizome, might be called **rhizomorphic**.

schizoanalysis – The exploration of identity as a collective persona in order to understand growth and development that employs a multiplicity of character traits, and which makes use of the unconscious as repressed memories and desires.

strata – The formation of immanence into objects and organisations as effects upon each other and which make up the consistency of the world in which we live. Looking at social/cultural life in this way is therefore a kind of *geology*. Not only do strata add layer upon layer of meaning to our daily interactions, but it is often possible to differentiate between strata only if they appear different, and so *strata* refers as much to the difference as to the layers.

time-image – The glimpse of duration that occurs when the logic of the movement-image is disrupted. This can be provoked by the disruption or or breaking of film language (long takes, still-life compositions, direct address to camera) or by the use of repetition, reflection, metaphor and other poetic devices. Historically, the time-image is a product of cinemas that had to rebuild after World War II (e.g. in Italy) or that opposed mainstream dominance (e.g. in France). Later cinema practices adopted some aspects of time-image cinema within the mainstream, creating hybrid-images and disturbing the political power of the time-image.

Index

8 ¹/₂ 94
9/11 terrorist attacks 103
10 Things I Hate About You 60
24 (Fox) 107
50 First Dates 98

AIDS/HIV 66–7, 70
Akinnuoye-Agbaje, Adewale
 120
Althusser, Louis 35
Alquié, Ferdinand xi
Amarcord 94
America Online 31
André the Giant 37
Andrews, Naveen 116
Anger, Kenneth 58
Antonioni, Michelangelo 93
Apple 31, 41
 iMac G3 31
Araki, Gregg 51, 58, 60–1, 63
Aristotle 3
Arnold, David 39
ARPANET 31
Atari 12
Atonement (novel) 87
Austro-Hungarian Empire 52

Badiou, Alain xii
Baer, Ralph 12, 21
Barrie, Dennis 69
Batman (1989 movie) 40
Battleship Potemkin 54
Baudrillard, Jean xi
Bazin, André 93
Being John Malkovich 98

Bergson, Henri xi, xiii, 85–9, 94,
 106, 108, 115, 117–19, 121
Big Brother 73
Bordwell, David 93
Borges, Jorge Luis 13
Borom Sarret 57, 61
Bourriaud, Nicholas 76, 78
Brazil (and minor cinema) 53
Brick 60
British Police Federation 24
Brookhaven National Laboratory 12
Brosnan, Pierce 39
Bushnell, Nolan 12

Capra, Frank 54, 62
Casino Royale 39
Cassell, Vincent 55
Cell, The viii, ix, 91, 99–106
Celluloid Closet, The 58
Certeau, Michel de 76
Chahine, Youssef 53
Chicago, Judy 71
Citizen Kane 94–5
Clarke, Noel 112
Cold War, the 97, 104
Columbine high school massacre
 20
Communism 32
CompuServe 31
Connery, Sean 40
Contemporary Arts Center,
 Cincinnati 69
Corbet, Brady 58
Corcoran Gallery of Art,
 Washington DC 68

Courbet, Gustave 67
Craig, Daniel 39–40
Creole (language) 52
CSI: Crime Scene Investigation
 (CBS) 107
Cusick, Henry Ian 121

D'Onofrio, Vincent 100
Dae Kim, Daniel 119
Dalí, Salvador 105
Dark Knight Returns, The
 (graphic novel) 40
DC Comics 40
Die Another Day 39
Die Hard 92, 104
'Dinner Party, The' (Judy Chicago)
 71
Doctor Who (BBC TV) 108–15
 'Blink' 110, 113
 'The Daleks in
 Manhattan 109
 'Evil of the Daleks' 109
 'Genesis of the Daleks'
 114
 'The Girl in the
 Fireplace' 112–13, 113
 'Human Nature/Family
 of Blood' 114
 'The Mutants' 114
 'Remembrance of the
 Daleks' 109
 'The Sunmakers' 114
 'The Tenth Planet' 114
 'The Visitation' 109
 'Dolores from 10h to
 22h' (Coco Fusco) 72
Dominguez, Ricardo 72–3
'Don't Tell Me' (Madonna) 98
Donkey Kong 16
Doom (video game) 16, 19
Douglas, Alexander 11

E.T. (The Extra Terrestrial) 63
East West Records 39
Egypt (and minor cinema) 53
Eisenstein, Sergei 54

Electronic Arts (EA) Games 40–1
Emerson, Michael 116
Empire State Building, the 93
Empire 93
Enzensberger, Hand Magnus 32–3,
 35, 38, 41
EON Productions 39
*Eternal Sunshine of the Spotless
 Mind* 98, 101, 104
European colonialism 7, 97
EverQuest 18

Fairey, Shepard 37
Fellini, Federico 93–5, 105
Flusser, Vilém xii
Foucault, Michel xi
France (and classical cinema) 91
Fusco, Coco 72–4

Game Studies (journal) 13
Garcia, Jorge 118
Germany (and classical cinema) 91
'Ghost' (Rachel Whiteread) 79
Godard, Jean-Luc 93
Gordon-Levitt, Joseph 58–60
Gothika 101
Grand Theft Auto (video game
 franchise) 11, 22–6
Groundhog Day 98
Guattari, Félix xi–xii, 4, 46, 127
Guerilla Girls 71
Güney, Yilmaz 53

Half-Life 16, 19
 Gordon Freeman
 (character) 16
 *Half-Life: Counter-
 Strike* 17
Hardt, Michael xii
Haunting, The 95
Hayes, Melvyn 48
Helms, Jesse (Senator, R-NC) 67–8
Henry V (play) 49
Higinbotham, William 12, 21
Hitchcock, Alfred 95, 105
Holloway, Josh 116

Hollywood (as classical cinema) 61, 96–7, 104–5, 125
'Holocaust Memorial (Nameless Library)' 79
'House' (Rachel Whiteread) 77, 78–81
Hume, David xi
Hustle (BBC TV) 107
Hyppolite, Jean xi

In Search of Lost Time (novel) 87
Indymedia 34
Internet, the xiv, xiv, 12, 27–41, 87, 124, 126
 virtual communities 18–19, 31
Intervista 94
Irreversible 98
It Ain't Half Hot Mum (BBC TV) 48
It's a Wonderful Life 54, 61–3
Italian Neorealism 93

Jacket, The 101
James Bond (franchise) 22, 39–40
Jefferson, Thomas (US President) 27

Kafka, Franz xv, 51–4
Kandinsky, Wassily 75–6
Kant, Immanuel xi
Kiasma Museum of Contemporary Art, Helsinki 72–3
Kim, Yunjin 119
Kinkade, Thomas 65
Kinsey, Mike 48
Klee, Paul xiii
Koundé, Hubert 55
Kuleshov, Lev 63–4
Kurdish identity (and cinema) 53

La Haine 55
Last Year at Marienbad 94–5
Latour, Bruno xii
Leibniz, Gottfried xi
Licon, Jeffrey 59
Lilly, Evangeline 116
Lockheed-Martin 21
Lopez, Jennifer 99, 101–2

'Losing My Religion' (R.E.M) 102
Lost (ABC) 108, 115–21
 'Everybody Hates Hugo' 118
 'Dave' 118
Lyons, Lisa 66
Lyotard, Jean-François xi

Madame de Pompadour 112–13
Madonna 98
Magnavox Odyssey 12
'Man in Polyester Suit' (Robert Mapplethorpe) 68
Manet, Edouard 67
Mapplethorpe, Robert xiii, 66–71, 74
Marnie 95
Marx, Karl 32–3
Massachusetts Institute of Technology 12
Matrix, The 101
May 1968 (political upheaval) 8
McEwan, Ian 87
McGugan, Stuart 48
Meet Me in St. Louis 63
Memento 98
Mercer, Kobena 67–8, 70
Metal Gear Solid 16
 Solid Snake (character) 17
Metro Goldwyn Mayer 39
Microsoft Xbox 12
Miller vs State of California 69
MMORPGs (massive multiplayer online role-playing games) 12, 17–20
Moffat, Steven 113
Monet, Claude 75
MTV 101–2
MUDs (multi-user dungeons) 12
Mulholland Dr. 101
Mulligan, Carey 110
Museum of Contemporary Art, Chicago 67
Myles, Sophia 113
Mysterious Skin 51, 57–64

National Endowment for the Arts 68
Need to Know 37
Negri, Antonio xii
New Queer Cinema 58
New World, the 7, 28
 the Americas 7
 Australia, New Zealand 7
New York Police Department 24–5
Nietzsche, Friedrich xi, 4
Nintendo GameCube 12
Noughts and crosses (Tic-Tac-Toe) 11

O'Quinn, Terry 119
'Obey Giant' (Shepard Fairey) 37
Orr-Cahall, Christina 68
Others, The 95

Pac Man 12–13, 15, 19, 21–3, 26
 Pac Man (character) 1 4–17, 19
 Ms Pac Man 16
 Pinky 17
Perfect Moment, The 66–9
Perrault, Pierre 53
Picasso, Pablo 65
Piper, Billie 112
Plato xiv, 3
Pong 12
Prodigy (internet service provider) 31
Proust, Marcel 87, 94, 106
Pulp Fiction 98

Quake 17, 19
Quebec (and minor cinema) xv, 53

R.E.M. 102
Radio Times 36
Rajskub, Mary Lynn 59
Rancière, Jacques 78, 123
RealPlayer 36
Resnais, Alain 53, 93–4
'Robinson Crusoe' (scenario) 115

Rocha, Glauber 53
Rodriguez, Delfina 72–4
Roma 94
Rouch, Jean 53
Ruiz, Raoul 94, 106
Run Lola Run 95, 98
Russell, Steve 12

Sage, Bill 58
Sanders Associates 12
Sebastian, Saint 102
Second Life 31
SEGA Dreamcast 12
Sembene, Ousmane 53, 57, 61
Senegal (and minor cinema) xv, 53, 56–7
Shaken and Stirred (album) 39
Shining, The 95
Sica, Vittorio de 93
Silence of the Lambs 101
Sims, The 16, 22
 SimCity 17
Sinclair Spectrum 12
Singh, Tarsem 102
Sliding Doors 98
Sony Corporation 39
 Sony Pictures Entertainment 39
 Sony BMG 39
 Sony Ericsson 39
 Sony Playstation 12
Soviet Union (and cinema) 54
Space Invaders 12
Spacewar 12, 21
Spellbound 95, 105, n135
Spider-man (2002 movie) 40
Spinoza, Baruch (Benedictus) xi, 108
Star Trek: The Next Generation 94
Star Wars Galaxies (video game) 18
Stewart, James 62
Strange Days 102–3
Super Mario Bros (video game franchise) 16
 Mario (character) 16–17
Survivor 73